A Brief History of Orillia

Ontario's Sunshine City

Dennis Rizzo

Foreword by John Forrest

Charleston · London
THE History PRESS

Published by The History Press
Charleston, SC 29403
www.historypress.net

Copyright © 2014 by Dennis Rizzo

All rights reserved

Cover images: Gazebo photo by Carolyn Campbell; Bell Tel truck photo from the OMAH Collection; log cabin image courtesy of T.H. Ware.

First published 2014

Printed in Canada

ISBN 978.1.62619.104.4

Library of Congress CIP data applied for.

Notice: The information in this book is true and complete to the best of our knowledge. It is offered without guarantee on the part of the author or The History Press. The author and The History Press disclaim all liability in connection with the use of this book.

All rights reserved. No part of this book may be reproduced or transmitted in any form whatsoever without prior written permission from the publisher except in the case of brief quotations embodied in critical articles and reviews.

CONTENTS

Foreword, by John Forrest — 5
Acknowledgements — 7
Introduction — 9

Chapter 1. Huronia — 13
Chapter 2. Indigenous — 23
Chapter 3. Pioneers, Missionaries and Land Speculators — 33
Chapter 4. Life After Furs — 45
Chapter 5. Invisibility — 59
Chapter 6. The Deal — 69
Chapter 7. Lumber Is King and Rides an Iron Horse — 81
Chapter 8. The Heydays — 95
Chapter 9. We Define Ourselves — 109
Chapter 10. World War and Change — 123
Chapter 11. Legacies — 137
Chapter 12. The Sunshine City — 149

Notes — 161
Bibliography — 171
Index — 183
About the Author — 191

FOREWORD

To quote author Dennis Rizzo, "Writing a history of a place I have lived in for just shy of three years was daunting."

Rizzo has met and exceeded that challenge. *A Brief History of Orillia: Ontario's Sunshine City* presents a remarkable, insightful and entertaining overview of Orillia's development, from prehistory to present. Rizzo's perspective as a "newbie" portrays, through unbiased eyes, Orillia's unique historical status. He reveals Orillia as not just an individual community but rather as a microcosm of the growth and development of Canada. The sun that has risen for eons over the ancient Aboriginal fish weirs links to that same sun symbolized on the flags of the City of Orillia and the Rama First Nation.

He begins at the source of it all: the geographical location where the twin lakes of Simcoe and Couchiching meet—where indigenous peoples gathered to harvest fish for thousands of years. His book takes readers on a journey through time, from pre-European contact across Champlain's Huronia, through the eras of fur traders, immigrant farmers and industrial entrepreneurs to the present day. Orillia remains a city constantly searching its history to define its future. *A Brief History of Orillia* will engage and enlighten, whether you have ancestors who fished one thousand years ago at the Narrows, traveled with Champlain, struggled to "prove" their landholding, crewed steamships on the Trent, assembled a Tudhope automobile or performed at the opera house or if you are reading the name "Orillia" for the first time.

Foreword

Rizzo's perspective as a recent arrival gives him a fresh direction with which to educate and entertain his readers, dispel some myths, explain the unusual and confirm some long-held beliefs. *A Brief History of Orillia* does so through the eyes and actions of those who created and still live in the cultural mosaic that is the Sunshine City. This chronicle validates and accurately reflects the words of Thomas Carlyle: "The present is the living sum-total of the past."

History is said to be written by the victors, but Rizzo's rendition depicts Orillia's history with an even hand, as it was created and lived by the participants and as the home and daily venue for famous and infamous people, activities and events. Over the years, the city has been held up as both a positive and a negative role model, often at the same time by different groups. It has seen it all but yearns for more.

Indeed, symbols on the City of Orillia's official crest depict much of its heritage, but it professes just a one-word motto: "Progress." From ancient times to modern day, this progress is faithfully recounted by this work, based on recorded fact, accepted opinion and intriguing mythology and all flavored with a Leacockian perspective.

You will enjoy the journey.

John Forrest

ACKNOWLEDGEMENTS

Writing a history of a place I have lived in for just shy of three years was daunting. Without support and help, it would have been impossible to complete even this modest offering.

I owe special gratitude to my wife, Elizabeth van Houtte, for her endurance of my obsession with writing this book, as well as for bringing me to Orillia in the first place. My twins, Ariana and Zoe, and my son, Michael, were the incentive to tell the story the right way. Ross Greenwood became my sounding board and writing mentor in hours of discussion over gallons of coffee at Apple Annie's. John Forrest offered sage advice and encouragement. Whitney Landis and Ryan Finn of The History Press were patient and resourceful.

John Craig and Andrew F. Hunter spent lifetimes gathering anecdotes and recollections that would have been otherwise lost. The Simcoe County Historical Society captured early life in its "Pioneer Papers" series. Mark Douglas and William Allen carry the memories of an entire people through oral tradition. Randy Richmond did a fine job of pulling local flavour from news stories. The Orillia Heritage Society is continuing the effort to record our lives for posterity. Hundreds of others have posted information on genealogical Internet sites and in small, family-centred publications. Without these resources, presenting this story would have been impossible.

Sheena Wescott-Sykes at the Orillia Museum of Art and History provided access to so much that I cannot even enumerate it all. Jennifer

Acknowledgements

Murrant at the Orillia Public Library archives had patience and knowledge to share and provided some critical scans. Mark Douglas listened to a white guy try to discuss native history and did not laugh; he helped, and I owe him several pouches of tobacco. Marcel Rousseau shared his deep knowledge of things Orillian and was a great factor in my level of comfort in completing this work. Jack Marshall and Charlie Harvie listened and explained. I only wish there had been time to bring all of the stories together in this limited space.

There will be another opportunity.

INTRODUCTION

In our every deliberation, we must consider the impact of our decisions on the next seven generations.
—Iroquois maxim

The history of Orillia as it is today cannot be easily separated from the history and development of surrounding towns such as Oro-Medonte, Atherley, Coldwater, Severn and Ramara. At a greater distance, the features of Lake Simcoe near Barrie played a crucial role in why Orillia developed as it did and in the timeline that it did. But Orillia and Atherley share a unique geographical element that, more than anything, was the reason for the evolution of the site into a village, town and city. Long before there was European settlement, there was *Mnjikaning*—the place where the fish gathered and were trapped in the weirs. Without this simple geographic feature and the sociocultural forces that embrace it, Orillia most likely would not exist.

A town tends to define itself on the basis of its heroes and the events that occur in and around it. Yet most mainstream histories ignore and pass over deserving individuals. Orillia is no different. We laud Champlain with a monument and remain ignorant of the contributions of Antoine Gaudaur, William Yellowhead, Jacob Gill and others. We look to Stephen Leacock as "one of us," despite his late arrival, but argue the value of the fifty-year-old Mariposa Folk Festival. We praise the men of our history, but somehow Mercy Manwaring, Mary Shilling, Margaret Barker and others are offered only as footnotes.

Introduction

There are others who have been linked with and by Orillia over the years. Many did not continue to live here after their careers advanced or moved here after they retired. Under the heading of "Favourite Sons…and Daughters," it is important to note that there have been many Orillians throughout the history of this town who contributed, sought no fanfare and lived quiet, fulfilling lives. Their stories require telling, probably more so than that of the famous "almost" Orillians.

In any small town or city, there are generally accepted beliefs about that town, its inhabitants and its history. Traditions, family lore and concepts taught in school—all of these evolve into what is termed "conventional wisdom." Orillians carry their own sense of the history of their town—traditions accepted as fact. These customs and tales become the conventional wisdom, shared by all to those who arrive later. This helps those coming later to assimilate, identify resources and feel a part of the larger community. The problem is that sometimes conventional wisdom gets it wrong.

History is quite often clouded, deliberately or unconsciously, by the times in which it is written, the people who write it and the purpose for which it is prepared. The story of Orillia—in fact, of all of Canada—is no different. Portions of the story of this town are as clear as a bell and can be easily supported. Other pieces are shrouded in layers of conventional wisdom and personal grandstanding. Still other pieces of the puzzle have been hidden away for so long that only a few people are even aware they existed.

People age, have families, start and end businesses, celebrate marriages, mourn deaths, build friendships, have differences and carry on with the everyday events of life. This process is as old as humankind. The talking points of a community are carried in official histories, public records and monuments. Everyday life has to be gathered from between the cracks and brought to the surface.

Many events and people are greatly underrepresented in written accounts simply because those who wrote the stories considered them unimportant. It has always been my opinion that the real story of a community lies with its *least* famous members. The difficulty often comes in assembling those accounts into a teachable message. It is particularly difficult when limited to a small book such as this.

It has certainly been interesting for an ex-pat Yank to look at a society that imitates British peerage. In the United States, class status was determined by wealth, as well as possibly by reputation (such as military

Introduction

action). Canada followed the British (European) tradition of class. Although there were a few knighted individuals (Sam Steele, for example), peerage in Canada appears to have come more from the manner and chronology in which one's family arrived. Surely, after confederation and independence, it appears that a more "American" social structure evolved. Business tycoons and politicians emerged with reputations and power to rival the most staid family lineage. But the overall impression that there is an "upper" and a "lower" class based on family history seems somehow to linger despite all evidence to the contrary.

I have tried to assemble the history of Orillia into a limited space. I have not attempted to be all-inclusive—to do so would be presumptuous. The purpose of this book is not to finish the story of Orillia. The purpose is to initiate discussion, encourage curiosity and foster further research and reporting. The purpose is to have Orillians take a peek at the range of emotions and events that have defined their Sunshine City. After all, Stephen Leacock might have lampooned Mariposa, but he still chose it as his home over so many other possibilities.

As a newcomer to Orillia, I am indebted to many folks for providing the large and small stories that help us, our children and our grandchildren better understand what has gone before, why we are where we are now and what is likely to come. There is one maxim on which historians should be able to agree: the more things change, the more they stay the same.

Chapter 1
HURONIA

On the Wampum belt of the Six Nations is marked the Council fire lighted up at the Narrows of Lake Simcoe at which place was put a white Rein Deer. At this place our fathers hung up the Sun, and said that the Sun should be a witness to all that had been done and that when any of their descendents saw the Sun they might remember the acts of their forefathers.
—Chief Yellowhead, 1840[1]

"Huronia" has long been a term for the territory roughly between Lake Ontario and Lake Huron, west of the Ottawa River and east of the Niagara Escarpment. It takes its name from the French for "boar," of which the first traders were reminded by the spiked hair of the Wendat.

Lakes Couchiching and Simcoe define the eastern edges of the city of Orillia. The Laurentian, among the oldest rock formations in North America, crosses from the Adirondack Mountains in New York State at the Thousand Islands and stretches northward to the shores of Lake Huron. It defines the extreme northern portion of old North Orillia.[2] South Orillia is the terminus of a series of glacial moraines.

Ancient portage trails and pathways skirt these two glacial lakes. To the west, one trail runs from present-day Hawkestone along a low ridge before turning sharply northwest. On the east, a second crosses at present-day Atherley and connects with the first trail in the vicinity of what is Bass Lake. Both then head in the direction of Matchedash Bay. From there, one can travel on the water all the way to the western tip

A Brief History of Orillia

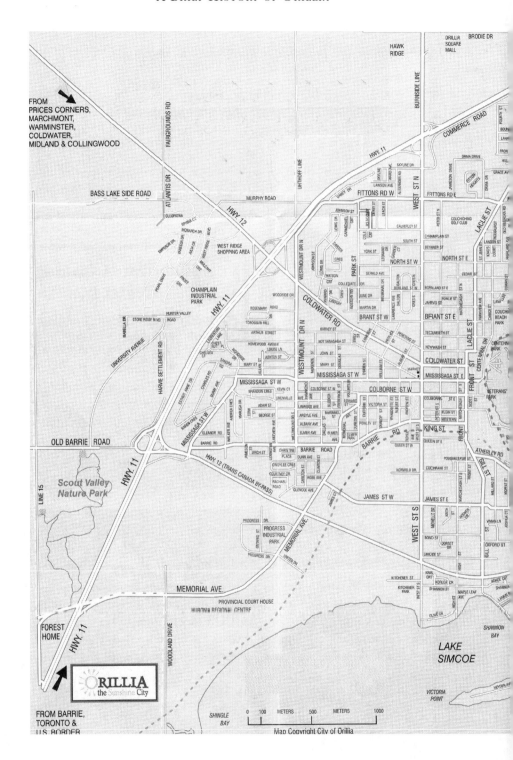

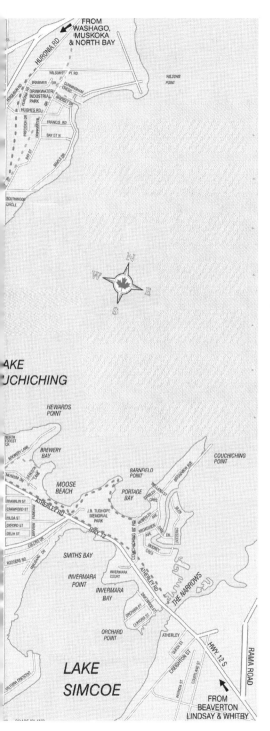

of Lake Superior and the interior of North America.

Eleven thousand years ago, glacial Lake Algonquin formed an enormous "Great Lake" ponded up in the Huron and Superior Basins as the last great ice sheet retreated north. It contained what are now Lakes Michigan and Huron, plus Georgian Bay.[3] Orillia was at the southern tip of the last great ice sheet and on the edge of Lake Algonquin. The prominent beaches and wave-cut bluffs are still visible today. One such shoreline can be seen two kilometres north of Orillia, just west of Lake Couchiching, at Brennin's Line Road near present-day Ardtrea.[4] A portion of the erosion that occurred as the lake receded can be seen as the bluff at the Couchiching Country Club—a hill known for hours of tobogganing fun in the winter.[5]

Orillia is dominated by two ridges. These run southwest-northeast, with a broad valley between the two. The westerly ridge is clearly visible from Fittons Road, the Highway 11 overpasses or the Coldwater Road. It contains housing built over the past twenty years. The easterly ridge runs past Westmount Drive, through Collegiate Drive and on up to Washago. The valley between, once marshland, is now a major retail

Chamber of Commerce Map, City of Orillia.

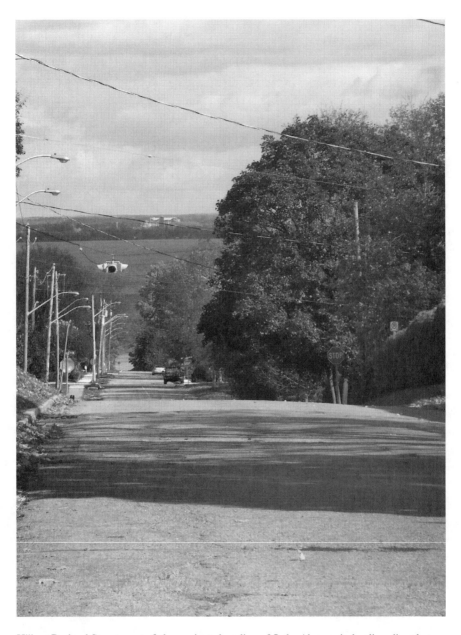
Hill on Borland Street, part of the ancient shoreline of Lake Algonquin leading directly to Lake Couchiching. *Photo by author.*

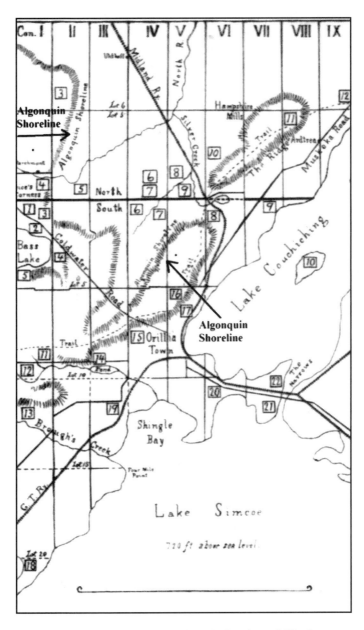

A.F. Hunter developed this map to show the locations of Wendat artifacts and remains. It also helps illustrate the topography of Orillia. *From* Ontario Archaeological Report for 1903.

location. The whole was once farmland in the old Oro Township, with Westmount Road the boundary of Orillia.

A.F. Hunter gave as good an explanation as any and illustrated it on his 1903 map of *Indian Villages*:

> *The "Algonquin" is a strong shoreline everywhere, but in the Orillia townships it is even stronger than elsewhere. At the town line between the north and south townships, there is a break where "The Ridge" in North Orillia is cut off from the high ground in South Orillia. Branches of Silver Creek take rise in this gap, becoming fair-sized streams; and the Midland Railway utilizes it for a passage.*[6]

The basin of Lake Couchiching changes from limestone in the South, at the channel from Lake Simcoe, to granite outcroppings in the North. These granite shelves are part of the Canadian Shield. The rocky outcroppings are visible as islands in the lake, as well as along the shoreline drives (Ontario Route 11 and Rama Road).[7] The transition is most obvious when you reach Washago while boating on Lake Couchiching or at the northern line of Severn Township on Highway 11.

This geological condition generally marks the line between land that is easily tillable and land that is not. It also marks the rough line of what is referred to as the Great Canadian Pine Belt—covering much of the land east of Lakes Simcoe and Couchiching and north to the Muskoka region[8]—where virgin growth red and white pine once soared over one hundred feet high and were thirty feet around at the base. This distinction would prove significant in the development of Orillia and Simcoe County.

In Pre-Contact times (before Europeans), this dense forest would have been particularly bountiful.

The First Nations of the Great Lakes region exploited close to five hundred plant species for food, beverages, food flavourings, medicines and smoking and materials for building, fibres, dyes and basketry. The diverse vegetation would have served as both home and food for a wide range of game animals, including white-tailed deer, turkey, passenger pigeon, cottontail rabbit, elk, muskrat and beaver.[9]

Both the soil conditions and the forests played critical roles in how (and where) Orillia emerged, how land was distributed and how fortunes were made and lost. Yet the natural element with the largest effect on

the location that would become Orillia is a small, almost inconsequential channel of water that runs from Lake Simcoe into Lake Couchiching.

The Atherley Narrows

Constriction of the flow of water from Lake Simcoe to Lake Couchiching forces spawning and migrating fish to concentrate in an area not more than one hundred meters wide. Ancient peoples did not miss this opportunity. Fish weirs (fences to funnel fish to places where they could be easily captured) have existed at this location for at least four thousand years, according to one archaeological dating source, and possibly nine thousand, according to another.[10]

The Narrows, about six hundred metres in length, originally consisted of a single meandering channel. In 1857, a navigation channel with a depth of between five and seven metres was dredged straight between the two lakes. This isolated a portion of the original channel that swings eastward and then northward into Lake Couchiching. It is in this portion of the original channel, with a depth of two to three metres, that the bulk of the remaining weir structures lie.[11]

Canoes used this passage for hundreds of years and fur-laden bateaux since at least 1640. The dredged (western) channel is part of the present Trent-Severn Waterway leading from Lake Ontario to Georgian Bay. Boaters travelling through this channel are merely following the route taken for centuries.

Many hundreds of years ago, oral history tells us, the Anishinaabe people's nomadic ancestors visited the area during a long migration from the Atlantic coast and learned the weir operation from the Huron people. Later, the Anishinaabe people returned to settle here and assumed the management of the weirs.[12] Oral tradition (and archaeological evidence) supports this site as one of the "holy sites" of the native peoples from far and wide. It was even used by tribes who were enemies. However, while at this place, there could be no animosity—no "bad vibes," as some would say. To allow this would offend the fish, and all people would lose a food source.[13]

The original channel served as one of the principal water routes from Lake Ontario (and what would become southern Ontario) to Georgian Bay, thence to Lake Superior and west. Before the new channel was

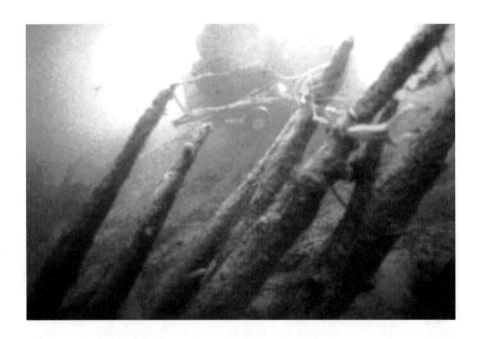

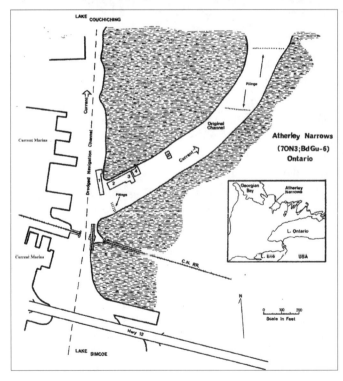

Above: Underwater archaeological studies of the weirs show that many remain in place. The area is now a national park. *Courtesy of Parks Canada.*

Left: Canoes used this passage for hundreds of years and fur-laden bateaux since at least 1640. The right channel is the site of the weirs. *From Ringer's "Atherley Narrows Fish Weir Complex."*

dredged in 1857, traders and immigrants embarking on larger steamships from Holland Landing had to land at Shingle Bay, Orchard Point or Invamara and walk one of the cart trails leading north along what would become the Coldwater Road.

The Iroquoian term *taronto* refers to the "stakes" in the channel at the top of Lake Taronto (Simcoe)—the weirs. It was applied to the trail leading to the Narrows (Taronto). Later, hearing the native term, the English applied it to the fort located in the village of York. The French name for Lake Simcoe, *Lac la Claies*—meaning "place of sticks"—was adopted by the voyageurs and traders.[14] Couchiching comes from either the Ojibwe word *gojijiing*, meaning "at the place of inlets," or the Cree word *kocicihk* (recorded in some documents as *ouchichiq*).[15]

To get to the Narrows water route from Lake Ontario required portage (carrying goods and canoes across country). Long before European settlers arrived, the Toronto Carrying Place consisted of two parallel trails. Later, French fur traders discovered this alternative to their traditional French River passage from Montreal via the Ottawa River. This "carrying place" was the route followed by Lieutenant Governor Simcoe on his initial trip of exploration.

One trail ran up the eastern bank of the Humber River and split at Woodbridge, with one fork crossing the east branch of the Humber and going up the west side of the river to the vicinity of Kleinburg. The other fork stayed on the east side of the river and angled cross-country to King Creek, joining the other fork before crossing the river near Nobleton. From there, it ran north over the Oak Ridges Moraine to the western branch of the Holland River and, from there, into Lake Simcoe, some eighty kilometres north of York (Toronto).

A second route ran from Lake Ontario at the Rouge River, followed the river northwest to the Oak Ridges Moraine, crossed the Moraine and met the eastern branch of the Holland River near modern-day Aurora, Ontario. This arm appears to have been favoured by the French explorers in the area, as they never mention the Humber arm.[16]

Once into Lake Simcoe, another canoe trail continues north through straits on the north end of the lake into Lake Couchiching. From there, the water trail follows the Severn River and its (at least) seven portages into Georgian Bay.[17] Voyageurs might also have taken the long portage trail that ran from the junction of Lakes Simcoe and Couchiching through present-day Warminster to Matchedash Bay at Coldwater and then by water to Georgian Bay.

The current keepers of the Narrows, the Ojibwe of Rama, deeply value their traditional role as stewards of the gathering place, *Mnjikaning*. To them, Atherley Narrows is much more than a fishing spot. It is a traditional meeting place for Aboriginal nations: a place for treaties, trade, festivities and spiritual ceremonies. To this day, as then, one-fourth to one-third of each catch must be released for future generations.[18] Later, as lumber became "king," this same stewardship was ignored by the barons of industry.

Chapter 2
INDIGENOUS

"Algonquian" (Algonkian) and "Iroquois" refer to the distinct languages of groupings of native peoples, not to a specific tribe or clan. Generally, Algonquian-speaking peoples lived to the north and west of the Lake Simcoe region, while the Iroquoian peoples lived in south-central Ontario (Northern Iroquois) through to New York State (Southern Iroquois). The Northern Algonquin peoples occupied land from about present-day Sudbury through to Manitoba and Minnesota and included the Anishinaabe or Ojibwe (Chippewa).

NATIVE POPULATIONS

Wendat and Tionontate were two Iroquoian-speaking nations, closely linked by their proximity and allied in most matters for many centuries.[19] The French referred to the Wendat were referred to as "Huron" by the French and the Tionontate as the "Petun." ("Wendat" may also be seen spelled as "Quendate.") These people were situated between Lake Simcoe (known to them as *Ouentironk*), Georgian Bay (the Penetanguishene area to the Blue Mountains) and the marshland south of Collingwood. The population of the Wendat and Tionontate ranged from twenty-eight thousand to thirty-one thousand from AD 1550 to AD 1609.[20] Recent

research seems to confirm that they evolved from peoples already living in what the French called Huronia rather than migrating to the area.

Archaeological and osteological data tend to support an *in situ* development of Wendat-Tionontate from Middle Woodland populations who inhabited south-central Ontario and document a gradual development of an Iroquoian way of life (e.g., the adoption of maize agriculture, longhouses and upland semipermanent villages).[21]

The mid-sixteenth century saw the development of a Wendat-Tionontate Confederacy, which was the organization in place when Champlain first visited in 1609. *Récollet* priest Joseph Le Caron arrived from Quebec via the Ottawa and French River route in early 1609. Samuel Champlain followed a few weeks later. (Le Caron is credited by Champlain as holding the first Catholic Mass in Wendat territory.)

There is considerable literature on Samuel de Champlain's exploration of what became Upper Canada. From his own notes and others' observations of his travels, the explorer held high hopes for a productive and mutually beneficial relationship with the native population in Canada.[22] There is ample archaeological evidence and oral tradition of regular trade between the Wendat and Tionontate and the Iroquoian Nations in New York, as well as with the Algonquian Ojibwe and others in the Northwest. The Wendat and Tionontate had been among the most important suppliers of furs to the early French traders and had established a fur trade network that served most of present-day Ontario and western Quebec. These trade relationships led them to become "middlemen" when the Europeans came to acquire furs.

At the time of Champlain's first visit, the Wendat and Tionontate were in conflict with the tribes of the Southern Iroquois (Mohawk, Onondaga, Oneida, Cayuga and Seneca). This war appears to have been one of periodic retaliation for attacks by the Southern Iroquois on Wendat and Tionontate villages. Champlain rendered some minor assistance in this conflict, with no real outcomes for either side.

In 1615, Champlain returned to the Wendat territory to firm up the alliance and fur trade. He spent some time in the community of *Cahiagué*. In what would prove to be a disastrous alliance, Champlain once again agreed to assist the Wendat and their allies in settling ongoing scores with the Southern Iroquois. This unfortunate and unsuccessful enterprise led to the eventual annihilation of the Wendat and Tionontate and the acquisition of their lands (at least temporarily) by the Southern Iroquois.

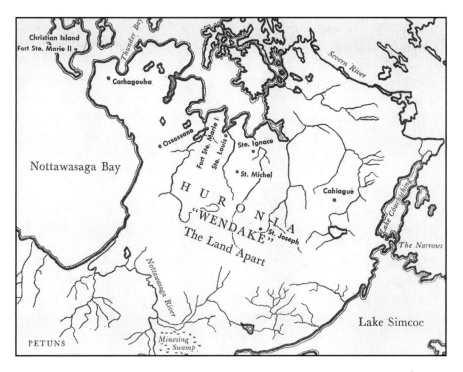

Along and near this long portage lay several villages, as identified through the years by A.F. Hunter, G. Warrick and others. *From Warrick's* A Population History of the Huron-Peton.

There were many villages in place at the time. These villages followed a similar pattern to the Eastern Woodland Iroquois, with longhouses arranged within a loosely stockaded perimeter. The perimeter would be strengthened in times of conflict or general hostility with neighbouring tribes. The reconstructed site at Ste. Marie Among the Huron in Midland is a well-researched example of a Wendat community. There were several smaller missions established in the area between the Orillia and Midland and west of present-day Orillia.

The Wendat had a large compound near present-day Warminster that has been thought to be the one referred to by Champlain and others as *Cahiagué*, but archaeologists continue to argue. There is another, larger village site referred to as the Ball Site, located off present-day Mount St. Louis Road.

The Ball Site (BdGv-3) is a proto-historic Huron site located near Concession 13, Oro-Medonte Township. As the crow flies, the site is

about half a mile south and west of the site at Warminster, now known as *Cahiagué*. It is situated on a high, sandy ridge that overlooks a broad, flat valley.[23] This site is older than *Cahiagué* and was clearly a principal village.[24]

Archaeological studies substantiate Jesuit and *Récollet* reports that the Wendat and Tionontate routinely maintained several dozen larger and smaller communities throughout the region. Both peoples typically relocated villages every ten to twenty years as sources of fuel and fertility of the soil eroded from use. It is likely that the central village spoken of by Champlain was one of many "principal" villages for the tribe. (See Hunter's map in the first chapter for sites uncovered by him and others.) It would appear that the Ball Site can be more confidently identified as *Cahiagué* and its European assemblage (artifacts) considered as characteristic of the circa 1590–1616/1623 era.[25]

The natives also tended to gather during various seasons in temporary villages, some of which might have had permanent or semipermanent structures throughout the year. One or more of these Wendat communities was located at or near the Narrows between Lakes Couchiching and Simcoe.[26]

Discovery of ossuaries in Orillia in the early to mid-1800s was an indication of long-term occupation by the tribe. The community burial or ceremonial sites appears to have been situated in a naturally sheltered area roughly between Mary Street, John Street, Nottawasaga Street and Westmount Drive. This area within present-day Orillia may have been a wintering site or related to a camp located at what is now Orchard Point.

Digging for house cellars and landscape disruption during the development of Orillia resulted in the loss of many artifacts and the dispersal of others. More importantly, it resulted in the disinterment of hundreds of native skeletal remains. From stories in circulation, and the reports of A.F. Hunter in 1903, many people were aware of these finds, but little was done to preserve the sites or to inform native leaders of them.[27] Remains continue to be found in gardens, cellars and construction sites to the present day.

It is possible that the place was specifically set aside for the interment of bones following the Feast of the Dead. For the Wendat, burial above ground on a scaffold holding a bark tomb was only temporary; a second burial of the dead took place as part of an elaborate community ceremony. In some Jesuit accounts, this occurred every eight to twelve years; in others, it occurred every year.[28]

The dead were therefore not simply released into a transcendent eternity but also kept in the neighbourhood of the living and of their own

material bones. It is as if the Wendat imagined them never completely dead or, at least, never quite departed from the living. And that is what the Jesuits found so fascinating in Wendat burial rites: the idea of a commitment to the dead that also celebrated the living.[29]

The ossuaries discovered along Mary Street and Nottawasaga Street in the nineteenth century follow true to the descriptions. But these are not the only significant sites in and around Orillia. A.F. Hunter spent many years studying and researching native sites. In 1903, he noted in a report to the legislature:

> *"[A] human skeleton with Indian relics" at the property of Mr. J.P. Secord at Orchard Point House, formerly the Red Cross Hospital. The burial was considered "recent" since it was accompanied by three brooches, a double-barred silver cross, about four inches long, with "Montreal" and the maker's mark upon it. The cross in this burial is similar to those placed with Christian Chippewa people of the late 1700s and early 1800s. In 1820 the original surveyor of Orillia Township measured an "Indian Clearing" at this same point, later called Orchard Point (Chewett 1820). In 1905 several more burials at the property of Albert Fowlie on adjacent lots at Old Oak Orchard Point also were reported to the Legislative Assembly of Ontario.*[30]

The clash of cultures remains in modern times. A condominium project was proposed for the site in 2007 but denied by the Orillia Council.[31] The condo project won on appeal and now sits on the site overlooking the Lake Simcoe entrance to the Narrows. It is supposedly a sign of progress, but it makes one wonder at what cost.

The establishment of semipermanent fur trading stations at or near that same spot in the late eighteenth and early nineteenth centuries is further evidence that the Narrows was an important gathering place for tribes from throughout the region—a rendezvous site. European traders would not have missed this opportunity to meet customers. In summer, bands congregated at food-rich shoreline locations, where trading and social activity occurred. In winter, when food was less plentiful, bands dispersed into smaller hunting groups.[32]

Archaeological evidence from the Dougall Site (BdGu-2) on Couchiching Point suggests a lengthy occupation during the spring and fall by women and children of both Wendat and Ojibwe peoples. The

Condos at Orchard Point were completed in 2012 after a battle about the protection of an extensive native camp and burial site. *Photo by author.*

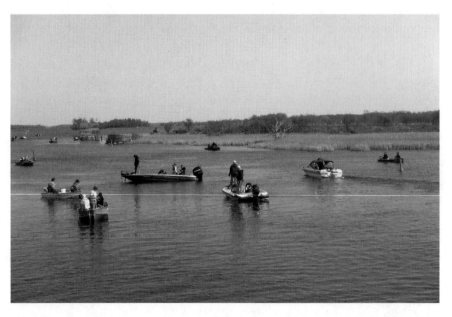

The original channel is to the right. Each spring, thousands of yellow perch and pickerel migrate through this waterway. Many end up as the main course on an angler's table. *Photo by author.*

site was seasonally occupied from nearly two thousand years ago until the present, starting with Middle Woodland peoples. More importantly, the site has been interpreted as a fish camp where fish were prepared for later consumption by either smoking or drying.[33]

Researchers believe, based on artifacts, that mostly women were engaged in processing the fish caught at the Narrows and that children would have accompanied them.[34] It would have been largely a sedentary task of cleaning and drying the fish for winter. The evidence confirms Ojibwe oral tradition and Champlain's description of the native use of the Narrows fishing grounds.

Weirs are designed to capture fish in large numbers. The Huron and many others smoked or sun-dried the fish. In addition, Huron, Mohawk and other Iroquoian tribes ate powdered dried fish. The Huron also prepared "sagamite," or spoiled fish, apparently preserved through natural fermentation.[35]

The significance of all of this lies with contradictory interpretations of the Narrows. In Euro-Canadian history, it is cited as a significant geographical route for trade, leisure and travel. It required alteration to fit the steamboats, railroads and developers. In native history, it is one of the sacred places from which life's needs are met. It requires maintenance but not change.

Population Changes

Between 1651 and 1701, southern Ontario went through three stages of population. After the dispersal of the Wendat and Tionontate in about 1650, it became a source of furs and a hunting territory for the Southern Iroquois. These tribes settled into the area from the 1650s to the 1670s. Second, the Southern Iroquois were dispersed by the Ojibwe and their allies (Mississauga and Ottawa). Third, European immigration displaced the Ojibwe.

Animosity between the Wendat and Tionontate Iroquoian people and those from New York predated European settlement. Intertribal warfare had existed in varying degrees of intensity for centuries in the region. For the most part, these were attacks of retribution, skirmishes to define tribal territories or raids for goods and captives. The arrival of Europeans

and the fur trade caused it to boil over into all-out war.[36] Whichever tribe controlled the fur trade controlled access to European goods.

The Wendat-Tionontate Diaspora can be traced to several factors, not the least of which was the decimation of the people by disease contracted from interaction with Europeans (Jesuits and their lay parties). This reduction in population alone would have strained any ability to sustain their culture and retain traditional territories. However, in retaliation for the Wendat-Tionontate attacks on their villages, Southern Iroquois raiding and war parties drove the Huron and the Jesuit missions from the area. By 1640–42, it was in the hands of the Southern Iroquois.

These new overseers continued trading with both the English (in Albany) and the French (in Montreal). From descriptions of the significance of the "gathering place" to all native peoples in the region, it is likely that they also made use of the fish weirs at the Narrows.

By the 1680s, the Iroquois had established agricultural and beaver-hunting settlements in the area. At the same time, the Ojibwe established settlements just north of the evacuated Huron territory. Finally, between the mid-1680s and 1701, the Iroquois were defeated by the Ojibwe and forced to withdraw from southern Ontario.[37]

From 1653 to 1662, years of trade, warfare and migration destroyed some tribes. But it seems to have also strengthened the growing solidarity of the Ojibwe. After this time, French (Jesuit) writers seldom mention the separate bands. Small groups still hunted by themselves in the winter, but the custom of gathering regularly in large villages for safety, trade, administration and religious gatherings gradually increased.

In an 1850 publication entitled *The Traditional History and Characteristic Sketches of the Ojibwe-Nation*, George Copway (or *Kah-ge-ga-gah-bowh*), an elder of the Ojibwe Nation, wrote of the "Huron Iroquois," stating that the Eastern (or Southern) Iroquois attacked them because of "the fact of their having enlisted in their favour the Ojibwe nation." Copway also said that before the dispersion of the Wendat-Tionontate by the Eastern Iroquois, the Ojibwe and Huron coexisted quite peacefully.[38]

The disruption of traditional ways, the movement of large groups of native people and the ever-growing desire for European weapons and tools all increased the importance of trade for the Ojibwe. To the west, tribes like the Dakota, Assiniboine and Cree were eager to get more of the guns, knives and other goods that made the neighbouring eastern tribes so powerful. For these items, they were willing to pay a high price in furs, and the Ojibwe quickly exploited this situation.

In the 1680s, after a significant increase of their warrior population, the Ojibwe moved from the defensive to the offensive by attacking and destroying Iroquois villages located throughout southern Ontario. Some of the Southern Huron who had been routed by the Iroquois and dispersed throughout Ontario joined in with the Ojibwe. Copway wrote out the reasons why the Ojibwe waged war on the Iroquois: first, for breaking a treaty of peace by murdering some Ojibwe warriors; second, to clear the way for trade between the Ojibwe and the French; and third, to regain the land of the Western Huron and, if possible, drive the Iroquois wholly out of southern Ontario. Copway also explained that the first battle of many was fought near present-day Orillia; the bloodiest battles were fought at Rama, Mud Lake and Rice Lake, and the last was fought at the mouth of the Trent River.[39]

In a note in his translation of Elizabeth Simcoe's 1911 diary, J. Ross Robertson stated:

> *The territory occupied by the Ojibwe nation was the largest in extent of any Indian possessions of which there is a definite knowledge. When the Champlain* [French] *traders met the Ojibways* [sic] *in 1610, their eastern boundary was marked by the waters of Lakes Huron and Michigan. The mountain ridge lying between Lake Superior and the frozen bay (Hudson Bay) was the northern barrier. On the west stretched a forest, beyond which was a vast prairie. On the south, a valley, by Lake Superior, thence to the southern part of Michigan. The land within these boundaries has always been known as the country of the Ojibways.*[40]

In his history, William Warren related that there are some Ojibwe scholars, as well as Ojibwe elders, who believe that a common language points to a historical relation between such diverse tribes as the Ojibwe, Blackfeet, Cheyenne, Arapaho, Miami, Micmac, Delaware, Shawnee, Pottawatomie, Menominee, Sauk and Fox, Cree and Ottawa. According to Ojibwe oral tradition, they were actually part of the confederacy known as the Three Fires of the Anishinaabe. The Pottawatomie and the Ottawa were the remaining two "fires" of that confederacy.[41]

The fundamental essence of Anishinaabe (Ojibwe) life is unity—the oneness of all things. In their view, history is expressed in the way that life is lived each day. Key to this is the belief that harmony with all created things must been achieved. The seven clans of the Ojibwe include Loon

(internal affairs/chiefs), Crane (external affairs/chiefs), Deer (caregivers/artists), Bear (medicine gatherers/protectors), Bird (spiritual leaders), Fish (philosophers) and Marten (warriors/protectors). All work in harmony for the good of the people.[42]

The people cannot be separated from the land, with its cycle of seasons, or from the other mysterious cycles of living things—of birth and growth and death and new birth. The people know where they come from. The story is deep in their hearts. It has been told in legends and dances, in dreams and in symbols.[43]

This belief was about to face its greatest challenge.

Chapter 3
PIONEERS, MISSIONARIES AND LAND SPECULATORS

*They who loved
The cause that had been lost and kept their faith
To England's Crown and scorned and alien name
Passed into exile; leaving all behind
Except their honour.*
 —*William Kirby,* The Hunger Year *(1877)*

Upper Canada

In 1783, with the Treaty of Ghent, England lost thirteen colonies along the Atlantic seaboard—a region soon to become the United States. Many of those who supported unity with the Crown typically had no choice but to leave their country and their lands and possessions. Some went to England, some went to other parts of the empire and others were provided with land in British North America (Canada). Many of those land grant recipients went to Halifax, along with British regiments reassigned there, or received land grants in New Brunswick in an effort to populate that region with English settlers. Most found that the land they received was insufficient for their needs and much more difficult to gain a living from compared to their holdings farther south.[44]

In what was to become Canada, British immigration policies prior to the American rebellion had been directed to containing the French interests of what was then called Quebec. This included most of what is now Ontario, which was part of New France. The Constitutional Act of 1791 created Upper Canada as an English-speaking colony with British-style administration. Prior to this, there had been limited settlement by French and English traders and farmers from Quebec and the United States.

Before 1783, the few Euro-American settlers in Upper Canada were French Canadians clustered along the Detroit River on the colony's western fringe. During the next two years, however, the region received about six thousand new settlers, primarily Loyalist refugees fleeing from the American republic or disbanded British and Hessian soldiers and their families. By 1791, the new province's population had doubled to fourteen thousand. Yet Upper Canada remained dwarfed by the swelling numbers of Americans to the south and east.[45]

Orillia was unsettled by Europeans at this time, although the existence of Northwest Trading Company stations around Matchedash Bay, Lac la Claies (Simcoe) and Lake Couchiching establish that Ojibwe at the Narrows and Coldwater had regular and extensive contact with traders.

From 1780 to about 1825, the Crown policy on land acquisition was to provide it free for settlers who would immigrate.[46] There was no comprehensive effort to develop Upper Canada in its own right until John Graves Simcoe was appointed lieutenant governor.

Simcoe arrived from England in 1791 and immediately set about to organize the means with which to populate his newly designated domain. He moved his capital from Newark (Niagara-on-the-Lake) to a good harbour at the western end of Lake Ontario. This was done to give distance between the capital and the new United States.[47] What is now a quick journey to view rival hockey teams required a two- or three-day effort at the time.

In a political move typical of the times, he called it York, after Frederick, Duke of York, George III's second son. The natives had a traditional portage route to Lake Ontario (the Carrying Place) at about the same location as Simcoe's new capital. Pointing up that Humber River trail, the natives referenced the place of the Narrows as *Taronto* ("place where the trees grow in the water"). The English took it to mean the place on which they were sitting, and thus we have Toronto.

Simcoe realized that to sustain the territory's economic contribution to the Crown would require more than fur trading. He arranged for the surveying of the territory on a greater scale than had been done so far.

He believed, due to his experience with Loyalists evicted from the United States, that there would be ample immigration to populate his domain.

Most furs brought from above Georgian Bay were shipped via cargo canoe through the traditional French River route: down the Ottawa River to Montreal, the principal staging area for the Northwest Company. This was the route that Champlain had initially employed to reach the Wendat. However, trading had been going on around Lake Couchiching and Lake Simcoe at least since the French arrived in Quebec. It had increased once the Ojibwe removed the Iroquois from southern Ontario and took over the trade in the early 1700s.

In August 1785, Deputy Surveyor General John Collins had been sent from Montreal to map and acquire the northern part of this trail from the Ojibwe. He negotiated for the purchase of "one mile on each side of the foot path from the Narrows at Lac la Claies to Matchedash Bay with three miles and a half square at each end of the road, as well as one mile on each side of the Severn River."[48] The Collins Purchase essentially outlined the future Coldwater Road.

On September 25, 1793, Simcoe, with a small party of soldiers and native guides, started northward along the old trail. They established the Pine Fort on the western branch of the Holland River, near the modern location of Bradford. Stopping only to rename Lake la Claies "Simcoe" in memory of his father, his party continued north to Lake Couchiching and then down the Severn River to Georgian Bay. Elizabeth Simcoe noted in her diary:

> *Oct. 25th*—*They rode 30 miles to the Mississaga Creek, then passed a terrible bog of liquid mud. The Indians with some difficulty pushed the canoe the Governor was in through it. The Governor went to see a very respectable Indian named "Old Sail," who lives on a branch of Holland's River. He advised him to return by the eastern branch of it to avoid the swamp. They proceeded about thirty miles across Lac la Claies, now named Simcoe, in which are many islands, which Coll. Simcoe named after his father's friends and those gentlemen who accompanied him.*[49]

Simcoe returned and planned a land route to reach Lac la Claies (now Simcoe) at a place named St. Albans, which we now know as Holland Landing. He followed the advice of the natives and ran this east of the swamp (the Holland Marsh).

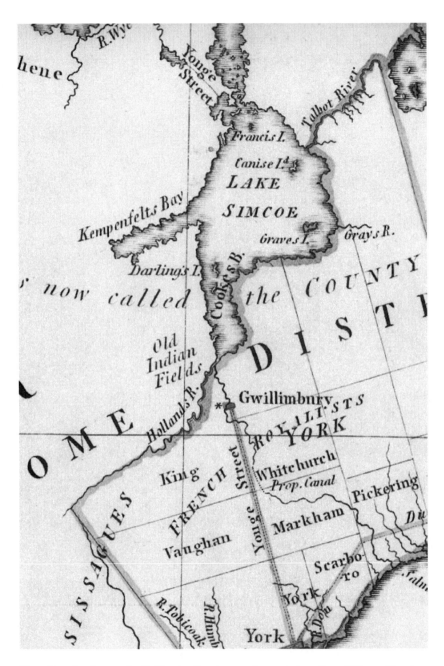

Note that what is now the Coldwater Road was to be a continuation of Yonge Street. *OMAH Collection.*

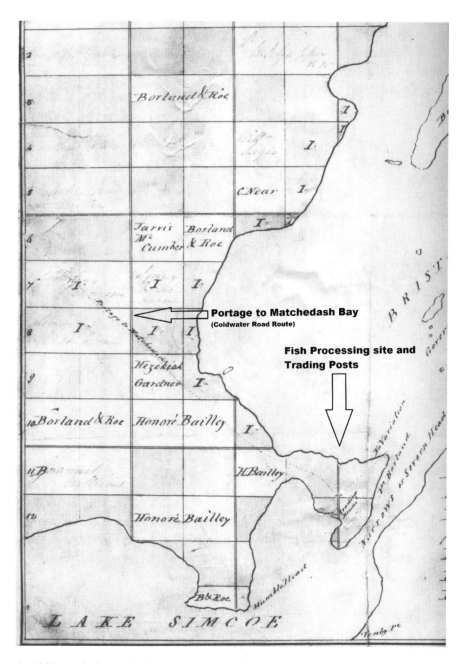

An 1830 map indicates "trading houses" at Orchard Point and also the portage route to Matchedash Bay along which Anderson planned his Coldwater Road. *OMAH Collection.*

Life in the Orillia area did not end because Champlain went home. From the time of the Ojibwe-Iroquois War, there had been little official settlement by or movement of Europeans into the area. These might be called "dormant" years but for the fact that the Ojibwe were busy trading and carrying on life as usual, without European recordkeeping.

During his journey of discovery, Simcoe passed and stayed at trading posts manned by longtime traders and voyageurs. This is clear evidence that the supposed period of "inactivity" between Champlain's visit to Orillia in 1615 and the arrival of English settlers after the War of 1812 was, instead, very busy:

> *Across the water of Matchedash Bay from the village of Fesserton— or, more precisely, opposite Bush's Point—are the remains of buildings known among the settlers there as "The Chimneys." On the shore at that place, you could see, as the name indicates, an assemblage of old stone chimneys that marked the dwelling place in the eighteenth century of an Indian trader and his family. About forty acres of a clearing were to been seen before the settlers came, and the stone foundations of some houses, while quite near the shore, were the remains of a larger building (with a stone well beside them). It was the habitation of an early trader named Cowan.*[50]

After the fall of French Canada, the English were quick to scoop up the legions of *coureurs de bois* and voyageurs who had chosen not to leave Canada. They did not simply disappear from the scene. George Cowan, also referred to as *Mssr. Constant* (reliable), continued his trade across Lake Huron to British-owned Fort Mackinac or via the French River route to Montreal. Cowan subsequently served as interpreter for the Indian agent (Johnson) in the transaction to purchase the site of Penetanguishene.[51] He was one trader with whom Simcoe states he had stayed during his journey in 1785.

But Cowan was only one of several static traders who operated posts throughout the region, including at the Narrows. Seasonal traders and their employees made use of Atherley and what would become Invermara (Orillia), Hawkestone (Oro) and Orchard Point (Orillia) as convenient locations for conducting business. Orchard Point was a significant native rendezvous site, adjacent to the fish weirs.

The landing places along the north shore of Lake Simcoe were various, but all were a continuance of the great trail across the isthmus

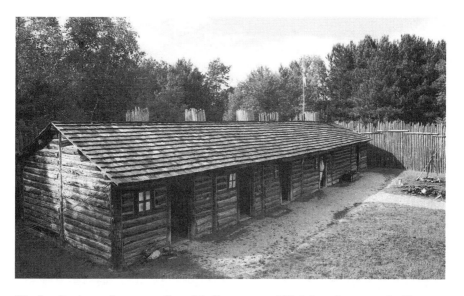

The "trading houses" were usually well-built structures. This is how the post at the Narrows might have looked. *Courtesy of the Minnesota Historical Society.*

of Hurontario. In the immediate vicinity of the Narrows, there were at least three of these landing places: the one on Lake Couchiching, where Orillia now stands; the Narrows proper, which marks the place at which the important trail leading to Port Hope crossed the waters of Lake Simcoe; and a third on the shore of Shingle Bay. The well-known firm of traders Borland, Laughton & Roe, of Newmarket and Holland Landing, had a trading post at the Narrows at an early date and maintained it for some years.[52]

Who Were They

One of those regularly mentioned as having an operation at the Narrows was Laurent Quetton St. George. He was the most successful member of a party of French Royalists, deposed during the Reign of Terror in France and given land north of present-day Richmond Hill by the English king. Under the leadership of Comte de Puisaye, they settled in 1798 along the newly laid-out Yonge Street.

Initially, residents of the Puisaye settlement lived in temporary barracks and worked together to clear the land and build houses. But as the spring of 1799 blossomed, servants brought from England deserted the enterprise for the freedom and opportunities offered by the New World. Melting snow and thawing ground made the road to York impassable for days at a time. There were long delays in the arrival of needed supplies.[53]

Quetton St. George had four hundred acres of land. Unlike the others, he did not sit around waiting for someone to till the soil. He soon realized that his fortune would be slow to come by farming and began to trade with the natives for furs. He shipped these to Montreal and New York, establishing a network of commerce. To better reach the natives, he established several *counters*, including one on the banks of Lake Couchiching at Orillia.[54] It is likely that he also had several voyageurs and natives on the payroll.

St. George left a ledger of activity at the Narrows in 1800–1802 that includes Ojibwe-French terminology. After 1804, he hired traders and moved his mercantile business to Niagara and York, in partnership with Dr. William Warren Baldwin.[55] According to A.F. Hunter, the natives called him *Wau-be-way-quon*, interpreted as "white hat," as it was his custom to wear a white hat in the summer season. In the notebook, Lake Simcoe appears to be called *Tepanignon*, but the meaning of the name is not clear.[56] One entry references Cowan and appears to say, "[O]ne can always find delightful entertainment at the place of Mssr. Constant, but at a dear cost." For the curious, the ledger is in the Baldwin Room at the Toronto Reference Library.

Stories are that traders were not averse to peppering a deal with whiskey to obtain an optimal price for furs.[57] Rum and *espirits* are commodities listed on almost every tally in St. George's ledger. It is likely, at first, that the traders were simply following European business protocol. The use of a stiff drink to seal a deal was widespread among European merchants and traders in all countries. In a sense, it was the three-martini lunch of the period. It wreaked havoc on the natives and taught less-than-noble traders how to get a good deal.

William Roe, the mayor of Detroit, emigrated from Michigan after the fall of the city to the British and Tecumseh (1812) and became a fur trader at the ford on the Holland River (also called St. Albans and Holland Landing) in 1814.[58] Early on, he partnered with Captain Andrew Borland as an agent for the Northwest Trading Company. That company was a conglomerate of Canadian and American fur dealers (eventually

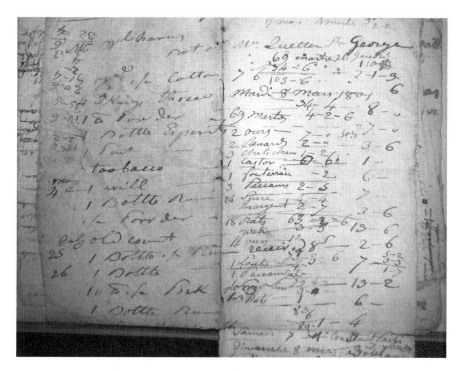

This list, from St. George's ledger, includes five bottles of rum and one bottle and one pint of *espirits*. Furs traded include sixty-nine marten, two bear, two fox, one beaver and several "rats-musk." *Photo by author.*

including John J. Astor) assembled as a Montreal-based competitor for the Hudson's Bay Company.[59]

Andrew Borland and William Roe had a warehouse and store at Holland Landing and are noted early on as trading at the Narrows. It is important to note that none of the traders worked alone. They all had native couriers and emissaries, voyageurs and workers preparing and carrying the pelts and trade goods. One of these was assuredly Antoine Gaudaur.

Two of the settlers noted in the 1832 census for what would become Orillia were sons of Captain Borland (Andrew) and William Roe (John). Both are listed as "traders with the Indians" and landowners. Under the terms of land allotment at the time, the descendants of those who had served the Crown were eligible for land grants in their own right.

Although it is generally thought that Orillia (as a village) started in about 1830, there were patents of land taken out much earlier. For example, Captain Andrew Borland and John Roe patented 2,900

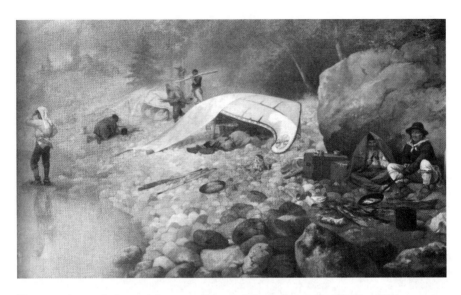
Voyageurs in a typical overnight camp. *From a painting by Frances Anne Hopkins, 1871.*

acres in South Orillia in 1821. This means that by the time we hear of missionaries operating a school (1828) and the farm instructors listed as working in Orillia (1832), there had been European land acquisition for at least a decade. Thomas Anderson's construction of the Coldwater Road makes much more sense, from a colonial point of view, when we consider that white farms had been developing all along that route for years, in the midst of the homes "built for the Indians" of which he speaks.[60]

On the map from 1830 (see page 37) is shown land patented by Borland and Roe, Honore Bailley (also spelled Bailey or Bailly) and others. Bailley was born Honore Gratien Joseph Bailley de Messein in 1774 in Quebec and went by the name Joseph. He headed a vast fur trading empire from Mackinac that competed with the Northwest Company and pioneered trading in Indiana.[61] It is probable that he or his agents acquired land near the Narrows trading sites on speculation. Antoine Gaudaur purchased several pieces of land on Orchard Point and elsewhere from either Bailley or Borland (the stories conflict).

A misleading listing on early Orillia maps is the continued indication of parcel ownership by Quetton St. George, who was deceased by 1830. Hunter helps by informing us that in March 1831:

> [T]he Upper Canadian Legislature passed an Act for vesting the estates of the late Laurent Quetton St. George in W.W. Baldwin. In the schedules at the end of this Act are printed lists of the lots and parcels of lands in Mr. St. George's estates. They include 2,500 acres in Medonte, 800 in South Orillia, and 2,300 in North Orillia, besides smaller parcels in other parts of this county.[62]

It is interesting to note that this action gave all of the property (and rights) to Baldwin not as a deed of sale but rather as an act of the legislature. It was this type of dealing that gave the power-brokers known as the Family Compact a bad name.

The merger of Hudson's Bay Company and Northwest Trading Company in 1820 had left many of the earlier Northwest agents out of work. This merger spelled the doom of most of the independent traders. As the fur trade moved to territory farther west, the emigrants from Europe arrived. Hudson's Bay Company continued a post at the Narrows up to the 1860s, at which time it was managed by Thomas Goffat.[63]

The native population, living in relative harmony with the traders and scant settlers for almost 100 years, was about to lose out to European monetary economics. It would take another 150 years before they would be able realign the flow of capital in their favour.

Chapter 4
LIFE AFTER FURS

The truth is that a woman of very delicate and fastidious habits must learn to endure some very disagreeable things, or she had best stay at home.
—Anna Jamieson

Is it a town, a village or a city? There can be some confusion when reading individual accounts, diaries and official documents about Orillia. Early on, it was referred to as the "Narrows at Lake Couchiching" or "Newtown." Hester Ann Gill referred to it by the latter. Mentions in other diaries refer to it by the former. By the point in time we have reached, Orillia was barely a community, but it was known as "Orillia." It is believed that the term came from Lieutenant Governor Peregrine Maitland, veteran of the Spanish Campaign of Wellington's army. The term generally means "shore of a lake or river."

The townships of North and South Orillia were created in 1843 when the government of Upper Canada proclaimed the Simcoe District. In 1851, another piece of legislation was passed that amalgamated the two townships into the township of Orillia. The new township was not resurveyed, and the Orillia Township Council frequently referred to the northern and southern divisions for clarification purposes (such as for militia rolls). In addition, Orillia retained administrative control over the township of Matchedash until 1888 and absorbed part of the township of Oro in 1903; sections of North Orillia remained in doubt until becoming part of Severn Township in 1996.

This certainly was not the intent of the colonial land agents.

Laying Out the Land

The Constitutional Act of 1791 established a Senate (Upper House) and a Lower House in British North America, including Upper Canada (Ontario). A second, significant element of the act was to specifically allow for private ownership of property. In general, it referenced land statutes in England.[64]

Before there could be settlement, there had to be land agents and surveyors. John Simcoe laid out Yonge Street and began to populate his new province with farmers and merchants, but it was the British land policies of the ensuing forty years that would determine the evolution of Orillia and countless other towns.

Land was surveyed in long strips about one mile wide called "concessions." The term meant that land not immediately desired by the Crown could legally be conceded or sold to someone else. Concession strips were then divided into two-hundred-acre lots that could then be further divided as the owner—or land agent—saw fit.[65] Roads that were of greater significance would receive names from the settlers. An example in Orillia would be Barrie Road or Coldwater Road.

The office of the surveyor general was responsible to the government for the fair and appropriate distribution of the land. Virgin areas of settlement had to be surveyed and mapped into parcels. Land areas reserved for the Crown and Church of England, "Clergy Reserves," had to be set aside. Perhaps the most influential factor affecting settlement and economic development was the monopoly exercised by the Family Compact.

The "Family Compact" is the epithet applied to an oligarchic group of men that exercised most of the political and judicial power in Upper Canada from the 1810s to about 1840. The uniting factors of the Compact were its loyalist tradition, hierarchical class structure and adherence to the established Anglican Church. The Family Compact emerged from the War of 1812 and collapsed in the aftermath of the Rebellions of 1837.[66]

Before about 1825, land was free, at least to the initial grantees. Resale was rampant. There were different conditions for those on good terms with the Family Compact. These large grantees often subdivided and sold their "free" land at immense profit. It was this process that probably encouraged Honore Bailley to invest in the Narrows. The following is a summary by Bill Shannon:[67]

- Land Grants—Given in lieu of pensions and as "gifts" for service in larger or smaller sections, with requirements for those not "in the loop" to clear and farm in order to obtain a deed. Larger landowners simply sold their rights to others. Some were granted thousands of acres for "service to the Crown" while others received as little as the minimum 100 acres.

- Clergy Reserves—Every seventh lot, specifically for Protestant Churches only, Catholics need not apply. This land was to be set aside for siting churches, cemeteries and (most often) leased out to farmers for cash to operate the church and pay the pastor. With plenty of cheap land, few farmers wanted to just rent from the church and, thus, these vacant lots frequently held up road development. This system was abolished in 1844, and these lands were given up for sale.[68]

- Crown Reserves—In 1823 thousands of hectares of land were sold to The Canada Company in one transaction to remove the legal obstacle to settlement of each township being banded by Crown Land. Land agents (some honest, some not so) became the middlemen for the immigrants. Later we will see William Ritchey, who worked Orillia.

With this government monopoly over land sales, and restricted clergy lands under control of the Anglican Church, it was virtually impossible for a new immigrant to settle a farmstead without incurring significant debt in the process. Even land conceded as "free," or granted for services, came with a hefty amount of string attached.

Working the Land

Improved postal service between the two continents—influenced by colonial administrations seeking to fill their farms, land agents hawking "free" land and the formation of land companies—encouraged immigration. Families already in Canada sent suggestions and instructions to those still in England or other parts of Europe. Many came under indenture to employers and worked, perhaps as maids, cooks, lumbermen or navvies on rail or canal projects.[69]

Starvation and overcrowding in the industrial centres of Britain resulted in a massive emigration starting about 1820. By 1830, masses of people in Ireland and Scotland were also in dire straits. At the time, parishes were responsible for supporting and assisting indigent and unemployed persons within their boundaries. In this period, widespread starvation and pressure on parish support of paupers coming from the clearances of Irish and Scottish estates[70] all had an effect on this migration. Many upper-class Brits felt it might be good to rid the country of the paupers rather than try to resolve the economic issues bringing about their existence. Coincidentally, the lumber transports returning to Canada had space, at about five dollars per head.[71]

Immigration was not a condition of ownership for those who had been awarded land on the basis of service (such as during the various colonial wars). Many of those of higher rank, with large grants of land, held it for speculation and/or sold to immigrating families through agents in England. Much of this land was purchased "sight unseen," and the process could resemble the "swamp land" deals of early Florida. The land grant policy changed after 1825. The Crown replaced its old policy of land grants to ordinary settlers in newly opened districts with land sales by auction.[72]

For those of average connection (or none at all) who immigrated and accepted the grant of land by the Crown, specific terms were in place for them to achieve deed to the property. A settler had eighteen months to do his settlement duties. If these were not met, however far along they had gotten in the process, they lost the land back to the Crown. (This would play into events in Orillia in 1835.)

The Upper Canada Council passed an order in 1818[73] that required that a settler build a house eighteen by twenty feet, clear half of the roadway in front of his lot and clear and fence five acres for every one hundred acres he had intentions of owning. So the early settler not only had to cut down trees on his actual property, but he also had to cut down the trees on what would someday become the road in front of his property. (And homeowners today complain about mowing that strip of municipal lawn.)

Most people learned "on the job," left or perished. Settlers and their families came with little or nothing of substance. Their tools and initial staples were supplied by government agents. Knowledge and "bush sense" was supplied by the immigrants who came earlier, the natives or by trial and error.

The European settlers who arrived in Orillia faced obstacles few had encountered before. According to government estimates, only one in six of the pensioners managed to endure life in the colonial wilderness. The remainder either died, unable to handle the physical hardship of life in the bush, or ended up destitute in the streets of the larger centres like Toronto or Montreal.[74]

James Ormsby was one who survived. A retired private in the British army, James saw no future in England and accepted the offers of land given in lieu of pension. James and his wife, Elizabeth, embarked on what would become a forty-year struggle to build a legacy from the virgin forest. They arrived in York late in 1830 and began the final leg of their journey north from York, most likely by stagecoach or cart along Yonge Street.

At Holland Landing, they travelled by boat up the Holland River—"a mere muddy ditch, swarming with huge bullfrogs and black snakes"— and then across Lake Simcoe to Hodge's Landing, a town now known as Hawkestone. There, they would have perhaps overnighted in a group of shanties that Wellesley Richey, the government land agent, had erected to accommodate the influx of settlers who arrived in Oro during the summer of 1831. James, Elizabeth and their three children then carried all of their worldly possessions over the six kilometres to their new home.[75]

The first Canada Company agent north of Lake Simcoe was Colonel E.G. O'Brien at Shanty Bay. He was succeeded in 1831 by Wellesley Ritchey. Ritchey set up his office at an ancient native landing place, near present-day Hawkestone. His crew built shanties that, from descriptions, were the first motels in the area. By 1832, Ritchey had moved his land office to the east side of Bass Lake, along the Coldwater Road, to be closer to the newer land sites that he was managing.[76]

Ritchey made some effort to accommodate the immigrants. He assigned a crew to build a family's first shanty on the land they had acquired. The agency shanty builders would cut out the space for a door and then leave it to the owner to hew inside as he liked and put in the door, window and floor if he could or live without them if not.[77]

In addition to finishing his home, the new immigrant had to clear the land. The gang method was the most rapid way to chop and log a quantity of land. Probably the single man working alone or with his son was the least effective. Consequently, wherever local population was sufficient, farmers cooperated in "logging bees" to make their labour more efficient.[78]

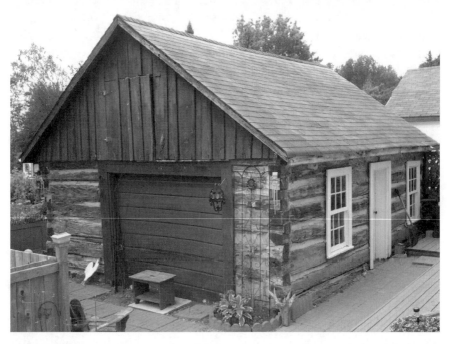

These two cabins, although somewhat modernized, fairly well illustrate the "second tier" home of the immigrant pioneer. Both still stand in the Orillia area. *Photo by author.*

Settlers built "improved" residences after the farmlands had been somewhat cleared and the first winter or so weathered in the cold shanty. These would still be "rustic" compared to later structures. Based on one estimate, it could take up to ten years for a settler to "own" his "free" land.

Getting Here in 1830

In about 1829, Charles Thompson started a daily stagecoach run from York to Holland Landing. It left at about noon and arrived at 7:00 p.m. the same evening, returning the next day. A rival line, the Northern Mail and Stage Coaches, left Church Street (York) two times a day and connected with the steamer *Beaver* on Lake Simcoe. A third competitor, the Peoples' Line, came into operation as well.[79] The modern motor coach has replaced the stagecoach, but the time from Toronto to Barrie feels about the same.

Stories of the travels of Hester Ann Gill, James Ormsby and Anna Jamieson certainly parallel the descriptions of this means of transport. Jamieson noted, "The Canadian stage-coaches are like those of the United States, heavy, lumbering vehicles, well calculated to live in roads where any decent carriage must needs founder. Conversation was kept up with wonderful pertinacity, considering that our vehicle was reeling and tumbling along the detestable road, pitching like a scow among the breakers in a lake storm."[80]

The accommodations were equally sparse. There was no *Michelin Guide* at the time, but it would appear that most inns rated about a half to two stars at the most. The Royal Hotel, run by Robert George, was in existence in the 1830s. Fraser's "inn" at Price's Corner (near the land agent, Ritchey) was in place. The Queen's Hotel in Orillia is mentioned as early as 1840 and actually was the first so-called welfare hotel in Orillia (in 1878, it housed the overflow from the asylum). On an 1843 map, A. Dunlop has a hotel at the end of Coldwater Road at the wharf. Stafford had another, five lots south on the shore, about where the Hotel Champlain is today. In between sat Taylor's Tannery and Shoes.

There were annoyances that have continued through to the modern era:

> [M]osquitoes are sailing about in all directions and make a great commotion against us, producing some exclamations, jumps, clapping of hands, etc....

A stagecoach. "Heavy, lumbering vehicles," as Anna Jamison said. *Illustration by Yudan Stanton in* Hills of Oro.

The mark…of the black fly is much more disfiguring, resembling much a little leech bite, the first prick being less painful. You would not readily imagine the amount of resolution it requires to sit still making a sketch when the flies are bad. The mosquitoes will bite through almost anything and the black flies are most ingenious in finding their way through all defences.[81]

The condition of the land was a challenge, as Anne Langton described:

This certainly is a country where the virtue of patience will not languish for want of exercise. One can scarcely realize the difficulty there is in making away with the wood that encumbers the ground, except when a good burning is practicable, until one sees it lying. The stumps must give every place a rubbishy appearance and the spreading roots prevent anything like a smooth pathway.[82]

In Orillia, there was little to welcome new arrivals. Hester Ann Gill describes what she encountered when coming to join her father, Jacob Gill, who had been working in the area for some time as a government contractor. The family had been living in Newmarket after staying from 1829 to 1830 in Penetanguishene, where Jacob was superintendent of commissaries:

> *In the spring of 1832, Father came here (to Orillia, that is) to engineer the building of the chief's house for the "Indian Department." Here as well as at Penetang the greater part of the lumber was sawn by men with what was called a whip saw. Until there was a Post Office all fathers letters that came were mailed to Penetang and then sent onto him once a month by the soldiers who brought the money to pay the men with.*
>
> *[At Orillia], the wharf was some trestles put out in the water about twelve feet apart and poles about six inches thru laid on them (the end of one laid between the ends of the other two) so that there was a pole and a space alternating and when we were on them the poles would spring up and down like a weavers treadle so we were very glad when we were on land.*[83]

Legend plays a role in how we interpret history. Thomas Williams, one of the surveyors for Ritchey, states that "Miss Mercy Manwaring came to the mission field and later married Andrew Moffat and their first child was the first white child born in Orillia."[84] This story can be found in numerous accounts of early Orillia, and while it has the potential to be true, it misses the essence of the early population.

Mercy Manwaring did arrive in 1831 (at age twenty-one in some accounts and age twenty-three in others) by canoe from Holland Landing. According to some, she wrote back to the New England Missionary Society for assistance. Based on what we know of extant postal service, this probably took several months to reach Connecticut. According to accounts, Andrew Moffat was sent in response.

However, the "census" of Orillia in 1832 shows only Andrew Moffat, Indian instructor, and makes no mention of the earlier teacher, Mercy Manwaring. Perhaps Mercy came after Andrew. Perhaps Mercy, as the woman, did not count in the census. It illustrates the fragile nature of "historical fact."

By 1832, there were several settlers in what would become Orillia, including Antoine Gaudaur, Thomas Anderson, Andrew Borland, John Roe and Jacob Gill. These were at the Narrows. Another group was listed in North and South Orillia Townships.[85] Of course, the Ojibwe had been present for at least one hundred years and were still living alongside the new settlers at this time.

For some reason, there seems to be a premium placed in histories of many of the English colonial settlements on identifying the first white child in an area. Perhaps it is a protocol akin to assigning significance to

Mayflower descendants in Boston. It serves only to skew the view of the beginning of "history" in a place and to minimize the contributions of the nonwhite and Métis populations.

It should be sufficient to note that a young woman came as a missionary, alone, to an unsettled area and lived here with her family until her death sixty years later. What determination and dedication that required. What a catch for Andrew Moffat.

Anna Jamieson was a world traveller long before it was deemed "proper" for women to travel alone, much less travel in the lands of the "heathens." Along with Mercy Manwaring and Hester Gill, she is an embodiment of early Canadian women. Anna gives us some of the best firsthand accounts of the water travel that Mercy most likely witnessed on her way to Orillia:

> *I counted seventy-two canoes before us, already on their homeward voyage—some to the upper waters of the lake—some to the northern shores; as we passed them, they saluted us by discharging their rifles…I could almost always see the rocky bottom, with glittering pebbles, and the fish gliding beneath us with their waving fins and staring eyes… The voyageurs measure the distance by pipes. At the end of a certain time there is a pause, and they light their pipes and smoke for about five minutes, then the paddles go off merrily again, at the rate of about fifty strokes in a minute, and we absolutely seem to fly over the water. "Trois pipes" are about twelve miles.*[86]

WHO'S ON FIRST?

It is often stated that Gerald Alley was the first white settler in Orillia. Alley was first employed as an Indian instructor in 1829 by Sir John Colborne's administration. William Law was missionary at Yellowhead's Island (now Big Chief Island) at least by 1828 and possibly earlier, as noted by Peter Jones: "Wednesday 18th 1828.—Chiefs Yellowhead and Asanee [*sic*] with their people, prepared to go to Yellowhead's Island, near the Narrows of Lake Simcoe. Brother Law is well calculated for a school teacher amongst Indians and they are much indebted to him for his indefatigable labours on Yellowhead's Island."[87]

A canoe was the method of conveyance on the lakes and rivers for centuries. *From Dolin's Fur, Fortune and Empire.*

Again, in 1829, Peter Jones noted, "We then had to sail four miles to Yellowhead's Island, on a little lake called Koochecheeng [*sic*], where Mr. Wm. Law, the school teacher, and his band of Indians, are encamped."[88] As a side note, Peter Jones was the Métis son of Augustus Jones, who had surveyed Simcoe's Yonge Street.

In addition, the landholders did not always perform their own work, particularly if they were speculators. The list of settlers does not tell us about the family members, servants, employees and others who typically accompanied landowners into a new territory. For the most part, the first white "citizens" of Orillia were not poor immigrants arriving in a virgin territory. Rather, they were experienced farmers, voyageurs and traders who knew how to make effective use of the land.

The myth of the province has been that the workers of the soil are its owners and that farms were forged from forest, swamp and slabs of rock by independent yeomen. Those who wished to take up land, among the large stream of impoverished immigrants who subsequently arrived in Upper Canada, engaged first in improving land for others or in wage labour on public works.[89]

GERALD ALLEY, Indian instructor, did not hold land title until 1832. Prior to that, he was a government agent, hired to teach farming to the

natives. He occupied "and improved" three acres of land within the current confines of the town, "for which he was to be reimbursed by the Indians should the property be returned to them." Based on his petition for lands to be received in service to the Crown, he asked for the deed to three acres of land, "which he now enjoys and upon the Indians leaving said locations for their new location in Rama, memorialist did to be made and erected improvements." He asked that the land be deeded to him without constraint. The petition was granted by the Land Office.[90]

ROBERT HONORE BAILLEY, the fur trader, is shown to have patented, on September 1, 1826, five hundred acres in the vicinity of the present town. He had a son, Robert. Based on land maps, the Bailley family or company retained many of these sections well into the 1860s.[91]

ANDREW BORLAND, the son of Captain Andrew Borland, was one of the first traders. Andrew owned land in Orillia and Rama in company with John Roe. John was the son of William Roe, one of three original partners in Borland and Roe. They are noted in the fur trade chapter. John Borland lived in Coldwater, apparently managing company property there.

JAMES DALLAS, sawmill owner and/or operator, was active in building the Orillia community. James and two of his sons served in the Orillia militia during the Mackenzie Rebellion but saw no action.

ANTOINE GAUDAUR (born in Quebec in 1797) saw service in the War of 1812, when he was just seventeen years old, under Thomas G. Anderson out of Michilimackinac in an expedition to Prairie du Chene on the Mississippi River. He married Mary Shilling, daughter of an Ojibwe chief called Big Shilling (contemporary of elder Yellowhead). It is likely that Antoine met and "courted" Mary during work in the area since their first son was born in 1819. This started one story of the Métis of Orillia. Antoine bought a lot near present-day Highway 12 and Atherley Road from Honore Bailley, perhaps his employer.[92] The "Gaudaur farm" location was across the neck of land between Lake Simcoe and Lake Couchiching, close to the current Stephen Leacock property. The Gaudaur family retained ownership of several plots of land in town, as well as in the surrounding area, for decades (much of it now in the city limits).

JACOB GILL, noted earlier, was a contracted millwright who brought his family to the area.

ANDREW MOFFAT, Methodist missionary, married Mercy Manwaring. Andrew ended up owning a large farm between what is now Atherley Road and James Street. Many older Orillians recalled the Moffat Farm.

JOHN ROE, one of the traders in the area, speculated in the land along with his partner, Andrew Borland. His family was originally from Detroit, where his father was mayor at the time of surrender to Brock and Tecumseh.

JONATHON SCOTT eventually became head of Methodist missions in Canada. Our first reference is in the *Methodist Chronicles*, where he is posted to Lake Simcoe Mission Station in 1829.[93] However, in 1832, Lake Simcoe Station and "Majudushk" show Gilbert Miller and James Currie. Perhaps Gilbert was working under Scott.[94]

LEONARD WILSON is listed as a government contractor, perhaps with Gill. Leonard, or his son, married Hester Ann Gill, daughter of Jacob Gill. Another son, Thomas, became a preacher and wrote numerous anecdotes about life in early Orillia. These were published in the *Packet* in the 1890s and make interesting reading.

JOHN THOMPSON, PAUL DARLING, MICHAEL BOWERS and PETER LAMB round out the list. Of course, there is also a listing of early settlers from South Orillia and North Orillia (Matchedash). These will be left as grist for additional studies and stories.

Chapter 5
INVISIBILITY

Many realities are hidden behind the wall of perception.
—*Toba Beta*

By 1830, the Ojibwe of the Simcoe region consisted, for the most part, of a few hundred members in three bands under Chiefs Yellowhead, John Aisance and Snake. The headquarters of Chief Snake's band was the island named after him in the southern part of Lake Simcoe. Yellowhead's band was located at Orillia and the Narrows, while Chief Aisance was settled at Coldwater.

The inevitable, incessant growth in European settlement brought with it demands for more and more land, as well as more pressure on the Ojibwe. In the eighteenth century, the Ojibwe had entered what European writers termed their "golden age," enjoying the benefits of close alliance with both the French and the English. But with those close ties came an increasing dependence on European guns, tools and liquor at the expense of the older way of life. In a sense, this cultural shift can be compared to the introduction of computers, cellphones and myriad electronic devices in modern times on which we have subsequently become dependent.

Initially, natives, missionaries, government agents and settlers coexisted. There was plenty of land, fish and fur to go around. But the population of natives could never effectively compete with the sheer numbers of Europeans. Things started to change, with challenges to landownership, the

reserve system, the determination to "Anglicize" the natives and the eventual establishment of the devastating residential school system.

YELLOWHEAD, AISANCE AND SNAKE

The War of 1812 was an opportunity for the Anishinaabe to solidify the hold on their land and territory and repulse American expansion. Many joined up to fight for their land, others surely fought for war honours and still others fought for the protection of their women and children—not just Yellowhead.

The important role played by Aboriginal peoples in the War of 1812 has not been well remembered. Throughout the traditional histories of the war, First Nations and Métis are either described as playing "support roles" in the military campaigns or not mentioned at all. Most references to Aboriginal participation in the war tend to focus on Tecumseh and his Shawnee followers and make only passing references to the Six Nations, the Ojibwe, the Dakota or the Mississauga.[95]

Orillia history focuses on William Yellowhead (Musquakie), the younger, because his was the band residing in what would become the town, and he was a principal chief for the Ojibwe. Musquakie has often been confused with his father, Omassanahsqutawah, also called Yellowhead, who had preceded him as an Ojibwe chief. "The Yellow Head, Chief of Lake Simcoe," who visited the British fort at York (Toronto) in 1796 was probably the father, as was the Yellowhead who visited York and Niagara in 1797. The elder Yellowhead was severely wounded in the defense of York in 1813, and as a result, his son, who was also present, was then made a chief of the tribe.[96]

Both Yellowheads are listed on the Orillia Canadian Legion cenotaph, along with Snake, Aisance and others, because of service in 1812. Both Aisance and Yellowhead also brought members of their respective bands to assist in putting down the Mackenzie Rebellion of 1837. This was just prior to their forced exodus to Rama. It would appear to have been a final effort—perhaps a need to prove themselves warriors, a status more in keeping with tradition than "farmer," and a unified people on equal terms with the English. There would seem to be no other rationale to participate.

Civilization

Each Anishinaabe clan had a special role in the organization and management of the tribe as a whole. The Ojibwe held to the "hunting-gathering" of their ancestors. The tradition was to maintain small, clan-based camps, with the people coming together either during key ceremonies or to hold council to make decisions for the tribe.[97] With treaties ceding lands in the area to the Crown, and the subsequent allocation of much of these lands to European settlers, the sustainability of this lifestyle eroded.

The response of Britain's office for colonial affairs was predictable. It saddled the Indian Department with the mission to settle down the natives and bring them into the European image. It embraced missionaries from a variety of religions who competed to bring Aboriginals into the fold. It arranged for instructors to teach farming to a seminomadic people and encourage a "sedentary" lifestyle. By the time of the establishment of the Newtown (Orillia-Atherley) settlement at the Narrows, the native peoples had essentially become dependent on British trade and treaty payments.

Between 1828 and 1845, the British Indian Department in Upper Canada went through a period of wholesale change. Under the control of the Johnson family for the previous eighty years, it had been responsible for maintaining the loyalty of various tribes during an age of imperial rivalry and revolution in North America. After 1815, this role became obsolete because the Indians were no longer necessary as military allies. New policies and administrative structures had to be devised. The Indian population was to be "civilized."[98]

With typical British colonial logic, the government arrived at the brilliant concept of land allotments for the native populations based on European landownership concepts. Land allotments of any type were termed "reserves." This application of the original land grant terminology to the natives is particularly distorted. The land grants termed "reserves" (as for the clergy and the Crown) were free allotments. The natives, however, paid for their reserves of land from their treaty allocations.

This policy emanated from England, not from the government of Ontario. It was up to the politically appointed lieutenant governors to design and enforce the regulations. Some bureaucrats made an honest if naïve effort to build a working system for the native populations; most

did not. Sir John Colborne was of the former sort and Sir Francis Bond Head of the latter. Both did their work through the Indian Agency.

Anna Jamieson became very sympathetic to the situation of the natives. Her various comments about them should be read with that in mind. While she had a Euro-centric view, she had adapted to the native philosophy during her long trip through Huronia: "To say that they cannot exist in amicable relation with the whites, without deprivation of their morals, is a fearful imputation on us as Christians; but thus it is… what chances exist, for the independence, and happiness, and morality of a small remnant of Indians residing on a block of land, six miles square, surrounded on every side by a white population."[99]

Before the 1820s, the government made little effort to confine the Ojibwe to their reserves. The Ojibwe continued to hunt and trade for furs as best they could. However, they were being displaced. The settlers cleared the land, depleting the game animals, and it became more difficult for the Ojibwe to support themselves by hunting. In addition, unscrupulous traders exploited the native people, cheating them on their furs and selling them alcohol instead of more useful farming goods.[100]

Some agents were patently criminal, and some were merely indifferently benevolent. The second agent for the Narrows and Coldwater, Thomas G. Anderson, is noted to have done all he could "in the face of public indifference and financial difficulty."[101] Anderson at least was familiar with, and sympathetic to, the situation in which the natives found themselves.

Captain Anderson was a veteran of the War of 1812 and was first appointed agent to St. Joseph Island (near Mackinac) because his father had served under Sir John Johnson. In 1820, Anderson married Elizabeth Ann Hamilton, eldest daughter of Captain James Matthew Hamilton, commandant of St. Joseph. This solidified his political standing. Notwithstanding grievances laid by Aisance in later years, Anderson was rather progressive for the period and spent considerable effort to find a way for the two peoples to coexist.

In 1815 and again in 1818, the Ojibwe agreed to annuities in payment for portions of their land (comprising most of Grey, Bruce and Simcoe Counties). However, in the usual way of cultural misunderstanding, the natives continued to hunt and travel through the area as they had before. The assumption was that the English wanted to "use" the land. The English now felt that they owned the land.

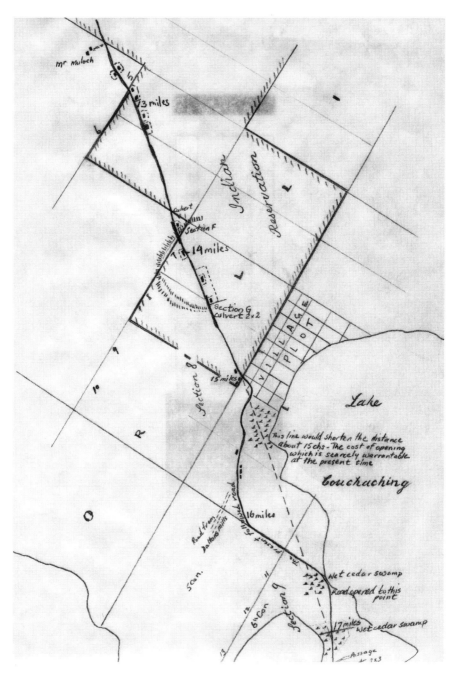

This map from 1835–40 shows the Coldwater Road as it was plotted, and the native reserve lands are marked clearly (squared plot lines). *OMAH Collection.*

In 1830, Lieutenant Governor Colborne became tired of complaints about natives wandering about lands granted to pensioners and settlers. Anderson was ordered to undertake the settlement and civilization of the three tribes of Ojibwe Indians under Chiefs Yellowhead, John Aisance and Snake at the Narrows, Coldwater and Lake Simcoe. At the same time, these tribes were becoming more dependent on the Europeans for sustenance.

The Indian Agency at Penetanguishene was moved to Coldwater. During the summer of 1830, Captain Anderson, with his family and his brother-in-law, James Hamilton (who was a surveyor), spent some time at what is now Orillia. With a crew, they engaged in surveying and cutting a road between Orillia and Coldwater.[102] Anderson and his crew lived in wigwams or bark lodges. There, they were honoured by a visit from Sir John Colborne, the then governor-general, who remained four or five days with them, sharing their lodge and simple fare and making himself quite at home, apparently delighted with the novelty of everything and winning all hearts by his kind and friendly manner.[103]

The natives used such shelters during the summer and while on hunting expeditions in the winter. It was the "camper" of the time. The shapes and forms varied based on the materials at hand and could resemble the traditional "tepee" or the round frame wikiup covered in skins or bark. We do not often think of a lieutenant governor, or any other politician, sleeping in such a structure for three or four nights other than as a publicity stunt. Colborne, following the usual British colonial tradition, was schmoozing with the locals.

By 1831, Lieutenant Governor Colborne had formalized Ojibwe settlement on the new Coldwater Road Reserve. At this time, there was already a variety of white and Métis settlers in the area. Interspersed with the native properties were white properties—some owned by those working them and other tenant property owned by land speculators or the clergy.[104] Yellowhead was provided with a "fine house," as befitted a chief. He is even listed among the "important men" of the town in early council meetings and sat on town committees. His house was located on Coldwater Road, about where the St. James Parish Hall is now, but it was demolished long ago.[105]

In 1835, Anderson submitted a glowing report of the progress made by the natives in working their small farm plots. Several thousand bushels of grain had been grown. Anderson and Gill had built a sawmill and gristmill near present-day Coldwater in 1833 and constructed another near Marchmont in 1835.[106] It seemed like the experiment was working.

Example of a wigwam or wikiup. Clothing in this picture is typical of the period when Anderson would have been living in such a structure. *Photo by author.*

Research suggests that this is the house built for Musquakie. The church seen behind the building appears to be St. Paul's. *From* Beautiful Old Orillia, *OMAH Collection.*

Orillia itself was barely a crossroads, consisting of a few houses, shanties and barns, as noted by Hester Ann Gill:

> *There were from twelve to sixteen log houses which had been built for the Indians, the school house forming the centre. They were built in the form of a "V." Above these were two larger houses, one for the farmer kept to teach the Indians and one for the minister* [Gerald Alley or Jonathon Scott]. *The greater part of these buildings were south of the Coldwater Road and for about three miles toward Coldwater there were at intervals houses on each side of the road the road built for the Indians before we came. Father superintended the building of the chief's house and then surveyed the Indian Reserve Lands thru to Coldwater.*[107]

Anderson's efforts were to build the means for the natives to be self-sufficient. Gerald Alley had been engaged in the process of teaching the natives farming since 1829. Both were hampered by a shortage of government funds and settler willpower. As we saw, Alley had to petition the government for acreage in Orillia as payment for his work. Government and missionary leaders were increasingly disappointed that the natives were taking so long to embrace farming and become "civilized" (by English definition).[108]

Anna Jamieson related what she was told by the settlers:

> *I enquired about the Indian settlements at Coldwater and the Narrows; but the accounts were not encouraging. I had been told, as a proof of the advancement of the Indians, that they had here saw-mills and grist-mills. I now learned that they had a saw-mill and a grist-mill built for them, which they never used themselves, but let out to the white settlers at a certain rate.*[109]

The initial effort to move from a seminomadic people to a static farming culture was never fully successful. Chief Yellowhead's legacy is that he kept his people together as a tribe, which had not happened with many other bands. The concept of "owning" the land was foreign to his people. The government had expected the natives to begin paying the cost of the mills at Coldwater and Marchmont by 1835. But they had little or no experience in handling cash transactions. They fell into debt and were plagued by other factors challenging their sustainability.

An 1840-era sawmill interior, with logs stacked and ready to cut. *Photo by author.*

A high child mortality rate is seen in a census of Ojibwe bands made in 1830 for the Indian Department. Among most bands, the number of children was just over half that of the adults, demonstrating that the Ojibwe had fallen below the number of children needed for population replacement. By 1830, there were only about 2,200 Ojibwe left in Upper Canada.[110]

There was little incentive for the natives to learn farming, and there was no serious support after Samuel Jarvis was promoted to superintendent of Indian affairs. As occurred all too often in the settlement of Canada and the United States, an honest agent like Anderson was unable to deflect the demands of the local landowners and businessmen.

The attempt at farming and the constriction of open lands made traditional, sustainable connections to the seasons and the forests difficult, if not impossible. All of this conspired to create, and then sustain, the concept that natives could not support themselves and were "like children"; this greased the process of educating natives to "become white," thus inevitably leading to residential schools and the total diaspora of indigenous culture and elimination of self-reliance.[111]

By 1837, shortly after Anna Jamieson travelled through, the tribes at Coldwater and the Narrows had reverted mostly to hunting for sustenance. Sir Francis Bond Head, the new lieutenant governor, held no interest in continuing his predecessor's policies.

Yellowhead, Aisance and Snake eventually succumbed to pressures from the influx of Europeans and the efforts of missionaries to diffuse the culture and displace the people. The fur trade, which had built European-style prosperity for the tribe, was gone. The introduction of alcohol by traders disrupted the native consciousness and way of life, and the introduction of religious abstinence as a solution to their addictions herded them into the fold of European influence and expectation. The promised support from the Indian Department dwindled; the bureaucracy expected them to be self-sufficient. They had been.

We saw that the Upper Canada Council Land Act required that a settler build a house, clear half of the roadway in front of his lot and clear and fence five acres for every one hundred acres he had intention of owning. It was difficult for European immigrants to fulfill the European standard. The Ojibwe were struggling against their culture and traditions to meet the requirements of keeping their land.

The battle was already lost, and they did not yet know it.

Chapter 6
THE DEAL

My father made him an offer he couldn't refuse.
—Michael Corleone, The Godfather

The attitudes of the white settlers toward the natives typically ranged from benevolent neglect to overt hostility. By 1835, the Europeans had decided that they no longer wanted to share the land with the natives. The missionaries treated them like children in need of taming and feared that they could ever be civilized. The white church members began to demand that the natives stay out of the church services, which led to growing animosity. In some instances, white farmers created legal issues or purposely damaged native property "for a lark."

Reverend Elliott, travelling minister for the Church of England, arrived in 1833:

> *In the evening I preached to the Indians in the school house at the village. Comparatively few of the Indians being at home, not above sixty or seventy of them attended, one of whom interpreted my lecture to his brethren. On the following morning I visited the Indian school, but there were scarcely any children in attendance, as most of them had gone with their parents into the forests.*[112]

Petitions against the Ojibwe by several of the settlers in Orillia resulted in determination that the natives had failed to meet the Land Act

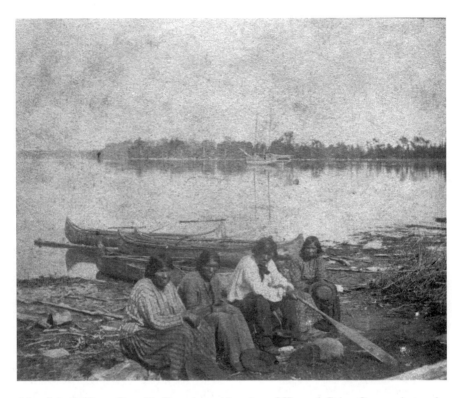

A beach in Orillia on Pumpkin Bay taken with a view of Hewards Point. One can just make out a schooner in the bay behind the natives. *C. Ellis, OMAH Collection.*

requirements and, therefore, that the land was to be returned to the Crown. Anderson convinced the Indians to voluntarily cede the land to the Crown in return for payment for that land. He has been castigated throughout history for that move. However, in thinking about how the Land Act was being applied under the Family Compact, Anderson was avoiding a total foreclosure, with which the natives would have forfeited all.

Yellowhead's options were limited. By then, the traditions of the people had been eroded, the ability to sustain themselves had been interrupted to the point where annual starvation was common rather than occasional and the only alternative was to move to the more remote, western regions of Upper Canada to join other Ojibwe bands or to acquiesce and stay in the ancestral area. Musquakie and Aisance chose the latter.

In later documents, a proposal is expressed by Samuel Jarvis, the superintendent of Indian affairs, "with respect to a portion of the Indian lands which on many grounds I think should be occupied by white settlers":[113]

> *The tract in question is situated in the Township of Orillia, Oro, Medonte and Tay and contains about 9,000 acres through which the road or line of communications between the Narrows on Lake Simcoe and Matchedash bay on Lake Huron passes…houses have been erected under the superintendence of the government for the accommodation of the Indians and are still in a tolerable state of preservation and could be rendered inhabitable at a very small expense. The Indian Chiefs and principal men of the tribe, finding that from their reservation being surrounded by a white population it became quite impossible to restrain the younger members of the community, prudently resolved upon changing their residence.*[114]

It is not clear what Jarvis is referring to. The difficulty encountered by the natives, causing them to resolve to change their residence, would appear more to have been perpetrated on them than caused by them. His proposal continued: "The proposition, therefore, which I have to make on their behalf is that the government should become the purchaser at an arranged price…paying them semi-annually the interest of three percent on the principal."[115]

This is interesting. It means that when you sell your house, the real estate agent keeps the proceeds and gives you 3 percent interest on the amount twice a year. You do not get to reinvest your profits: "The residue, say 7 & 8,000 acres, might be divided into 50 or 100 acre lots and an Emigrant family placed upon each in a month after arriving in Toronto, with the advantage of having sufficient quantity of land cleared ready to their homes, as would be ample for the sustenance of a family and many of them with comfortable homes to reside in."[116]

So, the Ojibwe were harassed off the valuable land from Orillia to Matchedash because they did not "conform" to the European code. They were considered not to have met the conditions of landownership. It was then proposed to Bond Head that the land be sold by the government. Their payment was the interest on the sale receipts—not the entire receipt. Jarvis hangs himself, and the government, with his last line: "I need hardly point out the great advantages which that section of the Province offers to industrious settlers—and as nothing more than the interest on the purchase is required I confidently hope that this proposition may meet with the favourable consideration of His Excellency."[117]

Sir Francis jumped on it. The council approved the proposition, stating, "[T]he sum of 8 shillings per acre may be stated as the price

that the lands may be sold by the commissioner of Crown Lands and the money received invested—so as to secure the interest for the Indians after sufficient deductions to meet any advances so far as necessary for that purpose (18 June, 1840 in Council)."[118]

The 1,621 acres in Rama that were offered to the tribe as an alternative were owned by five speculators, including Andrew Borland and John Roe, two of the original white settlers of Orillia. They were more than happy that their friends in Toronto had found a way to divest the poor land in which they had invested.

The area that had been surveyed to become Rama Township was one of the least arable in the region. However, sometime prior to 1838, William Roe (father of John), a store owner in Holland Landing, had acquired 97 acres in the township. Andrew Borland, son of the captain who had travelled to Canada with Jacob Gill, had acquired 594 acres there in the same area in an apparent partnership with William Laughton. Lieutenant Rook and John Coppinger had acquired 461 and 469 acres, respectively.[119]

Roe, Borland and Laughton were partners and well connected to the government; all three were land grant recipients and traders. It is not known whether they approached the government to collectively offer to sell their land in Rama Township to the Crown or vice versa. However, when the government agreed to take their non-arable land off their hands, they probably heaved a sigh of relief: "[B]y Indenture of Bargain and Sale dated December 1838, the five above-named agreed to sell their collective acreage in Rama Township totalling 1621 acres to the Chief Superintendent of Indian Affairs, Samuel Jarvis, to be held in trust for conveyance to the Crown." The Crown later sold it to Yellowhead's band for $3,200, which was deducted from funds owed to the band by the government.[120]

By June 1840, the tribes had reverted to hunting, gathering and petitioning the government for their promised annuities. The irony is clear in a statement by the Indian Department that all but admits that the natives had made a reasonable effort to conform while residing along the Coldwater Road. According to Superintendent Jarvis, that which was sold out from under them was (emphasis added) "sufficient quantity of land *cleared ready to their homes*, as would be ample for the sustenance of a family and *many of them with comfortable homes to reside in.*"[121]

Accusation of fraud in the transaction is to be found in an address made six years later to Sir Charles Bagot by Aisance and several other

An 1870 "road trip" to Rama, with native guides. The buildings approximate how Orillia Village would have looked in 1832. *C. Ellis, OMAH Collection.*

chiefs. They asserted that "when Sir F Bond Head insisted on our selling this Land...we were not made sensible of the full purport, so that we knew not the nature of the bargain."[122]

More importantly, there is evidence in a dispatch (#95) from Bond Head in 1836, proposing the removal of the Indians, that he and others were very aware of "the fact that many Indians were living on rich lands, with white neighbours execrating their indolence, drunkenness, etc., without making a single effort to improve them."[123]

In contradiction to those observations is a statement by Peter Jones found in Hunter:

> [W]*e read in the Journal of the Rev. Peter Jones, in June, 1827, when the distribution of presents was annually held at Holland Landing, how that Chief W. Snake complained of Mr. Borland and Philemon Squires, threatening to flog him if he did not leave off attending the*

> *Methodist meetings, and how that the traders were exasperated generally at the Indians becoming a sober people. Restriction of a few traders would have been easier than moving the entire Indian nations, yet such was the remedy proposed and partly carried into effect.*[124]

Borland was one of those profiting from the sale of lands at Rama. He was also supposedly one of the captains of the native force sent to quell the rebellion of 1837. He had been a trader with the Indians for many years, as had his father before him. He was accustomed to fuelling the people with rum to achieve his goals. However, a street in Orillia is named after him. The extent of similar activity by white settlers and businesses during the years before the removal will require additional research.

A passing comment in an article on education in early Ontario seems to say it all: "The early pioneers saw two obstacles to their community's growth—the native people and an inadequate transportation system. The first problem was dealt with swiftly and by 1839 the tiny township of Orillia had successfully petitioned the legislature to have the natives relocated to the east of Lake Couchiching."[125]

But that was not the end of the attempt to civilize the indigenous population.

THE MISSIONARY SCHOOLS

The child-rearing process of the natives, as described by Anna Jamieson, was one of firm but open and mutual respect. Even were this only partly accurate, the observation points to some of the issues faced in building a "school" system for the natives:

> *The Indians, apparently, have no idea of correcting or restraining their children; personal chastisement is unheard of. They say that before a child has any understanding there is no use in correcting it; and when old enough to understand, no one has a right to correct it. The will of an Indian child is not forced; he has nothing to learn but what he sees done around him, and he learns by imitation. I hear no scolding, no tones of command or reproof; but I see no evil results from this mild system, for the general reverence and affection of children for parents is delightful; where there is no obedience exacted, there can be no rebellion.*[126]

This method of raising children is not so far removed from what educational professionals promote today. However, the perception of such an individualist approach flew in the face of the methods in use by European educators. Missionary schools, no matter how progressive, were run on the European model.

Small, local schools were the norm, usually located within the church building. In addition, the early missionaries developed the methods and curricula alongside the natives. In the beginning, such missionaries as Moffat and Law had worked with native converts, such as Peter Jones, to build a unique schooling system. Hope McLean noted, "It was not enough that the native people should profess a belief in the Christian God; they must also be able to read the Scriptures and understand what was said in them":[127]

> *During the late 1820s, three major changes were made in the* [school] *program: the development of systematic bilingual instruction and the publication of supporting books in the Native languages; the adoption of the Infant School System, which was believed to be a superior method of teaching Native people; and the inclusion of a wider range of academic subjects. The Christian scriptures offered to the Native people by the missionaries and the European system of writing may have been seen as valuable by the Native people and more readily accepted because the Ojibwe had similar and equally valued practices in their own culture.*[128]

According to the Ojibwe missionary George Copway, the Ojibwe had a system of picture writing that was an effective means of communication. Introduction of texts in the native language would not have been completely foreign. The Ojibwe had long used a form of pictorial writing to preserve sacred traditions, religious rites of the *Midewin* and a code of moral laws, usually recorded on birch-bark scrolls but occasionally on rocks and outcroppings.[129] An example of the latter would be the pictograph of the Ojibwe victory over the Iroquois that could be seen on a rock in Lake Couchiching before that became submerged and eroded. Numerous similar pictographs can be found on Mazinaw Rock at Bon Echo National Park.

Early teachers used innovative techniques from England and Switzerland and readily sought input from the natives. It is believed that Andrew Moffat and Mercy Manwaring, at least, employed these techniques.

Sweet-grass basket copy of Couchiching battle pictograph by Jonathon Yorke of Rama, circa 1909. *Courtesy of the Royal Ontario Museum.*

The Infant School System, initiated in England, offered informal education starting at age five and using child-centred techniques that encouraged hands-on manipulation, group and individual learning and learning through play. The methods were later employed by Jean Piaget and Maria Montessori. The scriptures and other materials were developed in both languages, allowing the retention of the native culture. The natural environment of the students was incorporated into the learning process.

The early schools offered native teachers, bilingual instruction and pedagogy based on Johann Heinrich Pestalozzi, a Swiss educational reformer who emphasized teaching methods designed to strengthen the student's own abilities. The tragedy is that this productive and cooperative model of schooling was smothered and quickly forgotten by administrators.[130] Even though the ultimate objective remained to "civilize" the natives, at least the process allowed the student to learn a broad base of information in a manner that built on his or her culture.

In 1833, the Canadian Methodist Church joined with the British Wesleyan, forming the Wesleyan (United) Methodist Church in Canada, which appointed Joseph Stinson, an Englishman, as general

superintendent of missions. Stinson had no previous experience in working with native people and took a more rigid approach to the native missions. He was highly critical of the way they operated, to the point of ending many of the collaborative practices.

Over time, the various leaders looked to consolidate the local mission schools. Suggestions focused on a common factor, as presented in a letter to the Methodist leadership from General Superintendent Carmen and Secretary Sutherland in 1850:

> *It seems impossible to secure in the day school on an Indian reserve anything like a regular attendance, and in many schools the average attendance does not justify the annual expenditure. It is our conviction that a limited number of boarding schools, placed at a distance from the Reserves, would provide in the best way for the educational needs of the Indian children and that the present day-schools might be closed.*[131]

The Methodists did not close their day schools when they shifted to residential schooling. Throughout the 1840s and 1850s, day schools continued to operate at the mission stations; however, missionaries continued to complain about uneven attendance at the school because of family travels off-reserve. Diseases such as cholera and typhus swept the reserves, forcing the schools to close for long periods. Sometimes, school sessions were interrupted due to lack of teachers. The new Manual Labour Schools at Munceytown and Alderville accepted some day pupils from the surrounding reserves; expanding their reach was seen as a solution by all of the various missionary societies. The progressive local schools never recovered the momentum that they had during the 1820s and 1830s.[132]

At the proposed boarding schools, it would be possible to ensure that the students stayed in place and learned the proscribed curriculum. But that curriculum had changed as well. No longer was it in both Ojibwe and English. Stinson had seen to that. English was the language of the country (French notwithstanding), and English they would learn. The effective, broad-minded curriculum of the early school system was removed.

At the General Council of Indian Chiefs and Principal Men, held at Orillia, Lake Simcoe Narrows, on July 30 (Thursday) and 31 (Friday), 1846, the proposed removal of the smaller community schools and the establishment of manual labour schools was initiated. The chiefs present accepted the fact that the continuation of support and annuities necessary

The children were the tool used by the missionaries and the government to force "civilization" on the natives. *C. Ellis, OMAH Collection.*

for the survival of their tribes required them to accede to the demands of the reassuring missionaries. Anna Jamieson commented:

> *Without casting the slightest imputation on the general honesty of intention of the missionaries and others delegated and well paid by various societies to teach and protect the Indians, still I will say that the enthusiasm of some, the self-interest of others, and an unconscious mixture of pious enthusiasm and self-interest in many more, render it necessary to take their testimony with some reservation. The people who propose remedies, forget that there are two parties concerned.*[133]

The irony of this is that native students were not attending the local schools precisely because of the need for their families to return to hunting and gathering to survive. In the face of relentlessly frustrating treatment by local and national officials, the Ojibwe around Orillia had essentially abandoned farming and reverted to seminomadic ways. They hunted, led parties of white tourists into the woods and made baskets. When they left during hunting season or on long trips to obtain work, the children went with them. (Imagine that.) The typical imperialist solution was to clamp down harder and force the young generation to become civilized—on European terms.

The reserve system and the establishment of residential schools, intended to force the Ojibwe (and many others) into mainstream white

society, failed in meeting that objective. But it succeeded quite well in destroying an entire culture.[134] The legacy remains in and around Orillia to the present day and, while explainable, is unforgivable. The Anishinaabe vanished within Canadian society—a lost, wandering population that has only recently begun to reclaim its heritage.

Chapter 7
LUMBER IS KING AND RIDES AN IRON HORSE

An Act for the Union of Canada, Nova Scotia, and New Brunswick, and the Government thereof; and for Purposes connected therewith, whereas the Provinces of Canada, Nova Scotia, and New Brunswick have expressed their Desire to be federally united into One Dominion under the Crown of the United Kingdom of Great Britain and Ireland, with a Constitution similar in Principle to that of the United Kingdom.

—*Constitution Act, March 29, 1867*

Orillia had grown to eight hundred people by 1867, enough to become a chartered village. Steamboats had carried passengers and freight for more than thirty years, and lake traffic had increased with the dredging of the Narrows in 1857. The development of wharves and businesses along the lakefront is evident in images of Orillia at the time.

There were two major industries that initially made Orillia viable: farming and lumber. The increase in industrial economics, as opposed to strictly agriculture, meant changes in the method of earning a living. Lumber camps were attractive alternatives for off-season employment, and the railroad brought new opportunity for local workers. On the other hand, the expansion of businesses far outstripped the available workforce. The vacuum drew new immigrants, much as the oil fields in Alberta draw capable workers from others areas today.

Settlers arrived in record numbers between 1850 and 1870, and the population of the Orillia area had tripled from 653 people to 1,894

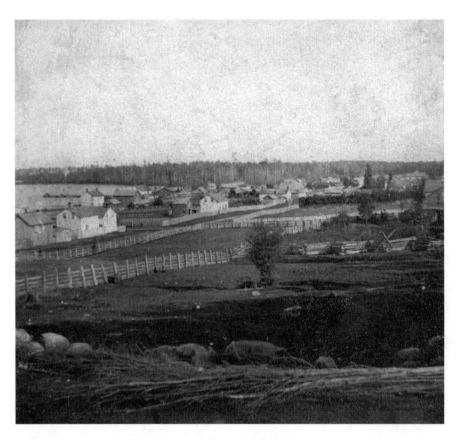

A view southeast from George Vick's property on the western side of Mississauga Street. Note the extent of undeveloped land in town. *C. Ellis, OMAH Collection.*

people by the 1871 census. By 1876, it had a population of more than 2,200, enough to be considered a town.

FARMING

Simcoe County and Orillia retained a great number of small, family-based farms into the 1970s. Ontario-born rural children were raised to the understanding that their families functioned like businesses. Children took from the enterprise in supervision, clothing and food and were

Familiar image of Oxford Street and the Moffat Farm, looking toward Gill Street and showing the residue of glacial rock deposits. *George Whiten, OMAH Collection.*

expected to repay their debts through their labour. They owed their parents "time."[135]

One of the ongoing tasks was removing the rocks deposited by the receding glacier. These had to be cleared from the fields before they could be properly ploughed. The task had to be repeated each spring as the thawing ground gave up more stones from its depths. As late as the 1950s, children were allowed away from school in May to help with this process.[136]

There were always farmworkers—sometimes seasonal and sometimes permanent. Some were apprenticed to learn a trade, and others were family members filling essential roles and hoping for their own farms. Some were hired hands, working for a wage. The labour was often backbreaking. "There have always been some men working year round for a single employer, but they have usually continued in these labour conditions only for a brief time as young men. Agricultural workers, historically and today, have been casual labourers dependent on irregular

spates of ill-paid waged work for several different employers in order to maintain material subsistence."[137]

In-migration brought new groups of Scots and Irish. Early Orillia depended on these unsung labourers as much as industrial Orillia did later.

Lumber

There had always been lumbering to one extent or another from the time the Europeans settled in Orillia. Trees provided the material of construction. Of course, there had been lumbering by the Wendat and Ojibwe long before. They harvested trees of specific lengths and widths for making and repairing the fish weirs in the Narrows, as well as for use with the construction of their villages. Commercial lumbering throughout Canada got its start when Napoleon Bonaparte cut off the supply of pine and spruce from Norway and Sweden. This was critical to the shipbuilding industry in England, which was at war with the French emperor. Extensive commercial lumbering and milling in Central Ontario started with the advent of the construction boom in Canada and the United States in the 1870s.

The lumber camps worked in teams. Initially, lumber was cut into square timber. This was easier to load into a ship for transport. By the late 1850s, this process had begun to give way to the milling of lumber into boards. A square timber gang included at least five men: the liner or scorer, who was the boss; the hewer, who was the most expert axeman; and two choppers and a hacker, who were rough workmen. The hacker cleared it off roughly, and then the hewer smoothed off the whole length of the tree with a broad axe. The process was repeated on the other side; the half-finished stick was then rolled over and the other two sides squared up.[138]

The workday at a lumber camp was long and rough. Work started at (or before) dawn and continued until dark. It was done in the fall and winter. Often, men worked in temperatures dipping to forty below. Sunday singing and impromptu games and dancing did little to soothe the loneliness.

Many were local farm boys who had gone to work for hard money. Almost 80 percent of farm men went lumbering at one point or another

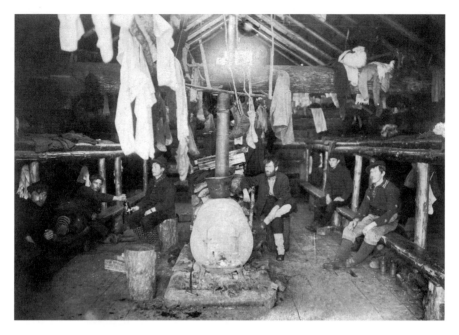

Life in the camps was hard and boring. Notice the bottle passing between the two men on the left. *OMAH Collection.*

in their lives.[139] As the clamour for lumber rose, and the mills were built to mill it, there was a need for more workers than the local population could provide. Seasonal lumbermen came from near and far to fill the gap.

The food was typically boring and often badly prepared. Song lyrics tell of the fare at one camp:

> *There's black strap molasses, squaw buns as hard as rock,*
> *Tea that's boiled in an old tin pail and smells just like your sock.*
> *The beans they are sour, and the porridge thick as dough—*
> *When we have stashed this in our craw, it's to the woods we go.*

In another camp the men were luckier (or less fussy):

> *Our cook's name's Jack Dunnigan, the best in the woods.*
> *His beans they are great, and his bread it is good,*
> *And his elegant sea pie will make quite a meal*
> *For the boys that are labouring for Martin McHale.*

Orillia served as the support base for many of the logging camps. By 1870–71, gangs of lumbermen were arriving in the fall, spending a few days in one or another of Orillia's hotels (and saloons) securing jobs and then shipping off to their camps for the winter. Lumber barons like John Thomson and Andrew Tait came to Orillia to build empires from wood.

Mills were constructed along the waterfront of Orillia. One was located on the site of present-day Couchiching Beach Park, and others were located at the foot of Colborne Street or along the shoreline. Before the railroads arrived, Orillia's harbour was often clogged with lumber "booms." Thomson's Longford Mills produced 5 million feet in 1869 and averaged 15 to 20 million feet per year after that until the timber ran out about ten years later.[140] After that, he brought timber in from farther north, when Bracebridge replaced Orillia as the support town for logging.

Lumber was stacked all along the lakeshore of town, adjacent to the mills. According to the curator at Upper Canada Village, milled lumber requires one year for each inch of thickness to cure properly.

BYPRODUCTS

Larry Cotton[141] revealed that in April 1876, a Toronto newspaper classified Orillia as one of the most notorious towns for wickedness and drunkenness in Ontario. The *Orillia Times* noted by 1877 that "murderers and burglars find a paradise in and around Orillia. We also venture the opinion that no other community in Canada can produce a record half as disgraceful as ours."[142] Who knows if this was a jibe at those who openly fed the "animal" instincts of the lower classes.

On the other hand, the temperance movement had its own reputation. The *Orillia Times* noted, "They are as illiberal, tyrannical, bigoted and oppressive in their own way."[143] It is likely that the editors of both the *Packet* and the *Times* were appalled, in good Victorian fashion, with the antics of the working classes.

Men in the northern lumber camps were isolated for all the winter months. Once the snow came, they had to settle in until spring. Before the era of radio and television, their only entertainment was what they could make themselves.[144] The crews that manned these camps cut the timber in

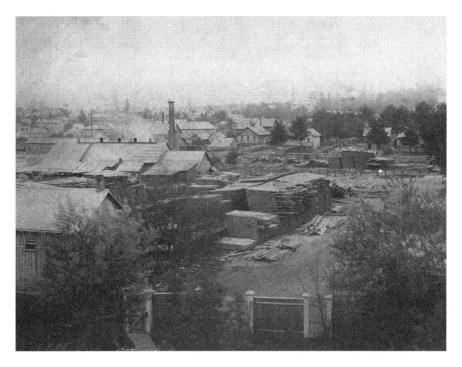

This view from the asylum shows stacks of wood drying near what is now Canice Street. In the distance is Tait's Mill at the foot of Colborne. *OMAH Collection.*

temperatures forty below, manhandled the rafts of logs and worked for a few dollars per week. When the season ended, it was as though cowpokes had finished a cattle drive and been paid off. Orillia resembled scenes from movies about Dodge City. Women were afraid to walk the streets, even in groups. Men stayed away from the taverns unless they had a strong constitution or were looking for some "fun." Shantymen had been known to lose an entire winter's wages in one drinking bout, and villagers were often afraid to venture out on spring evenings when the shantymen had returned from the bush.[145]

The call of the temperance movement was already being felt in Orillia as early as 1870, and adherents clamoured for action. Among those were Robert Hoy's lodge of the Independent Order of Good Templars and the Catholic Temperance Society. By 1874–75, the rowdy shantymen, joined by the railroad navvies, had created an atmosphere that led to an increase in town constables and an eventual ban on all alcohol sales in Orillia under Ontario's 1864 local option legislation.[146] The ban was not lifted until 1965.

A Brief History of Orillia

Feed It and It Grows

Support for the farming community and lumber industries could be found in the general stores and merchants supplying essentials. George Vick arrived in Orillia via Rochester and Toronto in about 1848 and got into the business of importing teas and fruit. He was one of the first to open a traditional dry goods and produce store in 1856, and he opened a bakery as well. The bakery was located originally about where the municipal parking on Mississauga Street is today. His sales location was across the street. He would be pleased that the present-day Mariposa Market and bakery occupies the site of his building.

George died in 1867, and his son, Herbert Vick, took over. The company grew, and by the early twentieth century, it had opened three distribution bakeries. Vick and Sons became so large that it took over the Church Brothers sawmill at the foot of Coldwater Street and turned it into a gristmill (the one in all the Orillia books) to supply the bakeries with sufficient flour. Vick eventually sold out to Canadian Wonder Bread–Northern Bakeries Limited.

Sam Wainwright opened the Orillia Tannery at King and West (or Chemong) Streets in about 1857 and also operated a harness shop with his brother, Arthur, at the bottom of Mississauga Street. Robert Hoy operated a harness and leather shop at 98 Mississauga Street. Leather was used for critical components of farming, lumbering and other manufacturing. It is quite likely that Wainwright, Hoy and others provided leather driver belts of various sizes to at least some of the contractors building in Orillia and area. Of course, they provided more mundane daily requirements as well, such as harnesses and shoes.

Ironworking was also essential to farming and lumbering. William Tudhope opened a blacksmith shop in 1864 at Andrew and Colborne Streets, and his son, J.B., went on to found the Tudhope Carriage Company, of which much has been written. As of 1865, Bateman's foundry made machinery and parts for many of the businesses in town, including the gristmills and sawmills. In 1878, Robert Brammer bought the foundry at the northeast corner of King and Peter Streets, naming it Victoria Foundry and Machine Works. In 1894, Brammer died, and his son-in-law, Erastus Long, took over. E. Long and Company became a long-term Orillia employer.

During this same period, small churches evolved into parishes, with formal buildings to serve their members. The Anglican and other

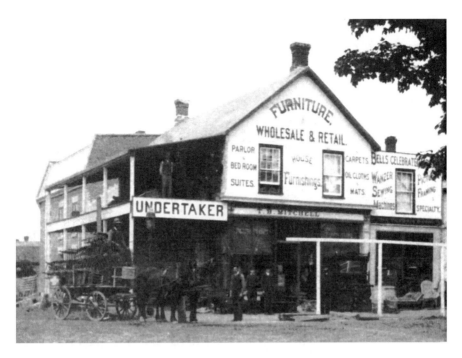

Many entrepreneurs operated more than one business under the same roof. From 1872 to 1888, Mitchell served his customers from cradle to grave. *OMAH Collection.*

"Protestant" Churches had one advantage over the Catholics and the smaller sects (such as Quakers). In the distribution of land, the Crown had allotted one of every seven lots to the Clergy Reserves for Protestant sects only. This gave those churches a leg up on the competition—they had land that they could lease for cash or sell for a profit.

The first place of worship in Orillia was the old Indian Council Chamber, erected in 1831 by the government on approximately the same site as the present St. James Sunday school building.[147] Early missionaries of all denominations held services here, and it became known as the Old Mission House. This is the church in which the Ojibwe were taught until their move to Rama.[148]

By the time it was chartered as a village, Orillia had become somewhat of a "wunderkind." Its growth was based on an increase in lake traffic, as well as lumber and tourism ventures. Dozens of small- and medium-sized businesses came to support these industries and the growing population of the village. The railroads, having stopped short at Barrie, began to plan for branches to and through Orillia.

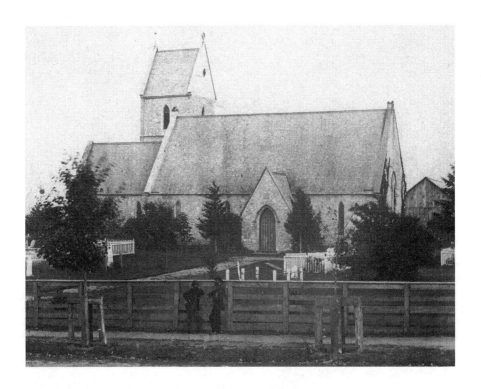

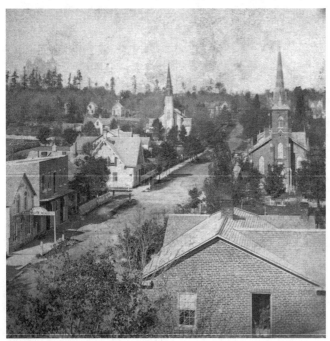

Above: In August 1857, the new St. James stone church was officially opened. The site is shown on maps as the "English Church." *C. Ellis, Vick Fonds, OMAH Collection.*

Left: This view shows St. Paul's and St. Andrew's in about 1871–72. The Irish church (Catholic) was a log building on Coldwater Road at this time. *C. Ellis, Vick Fonds, OMAH Collection.*

During the mid-nineteenth century, civic leaders enthusiastically welcomed their town's economic growth and development. They expected that the arrival of the railroad would further facilitate population growth and enhance Orillia's strategic position as a service centre for northwest Simcoe County. The partial fulfillment of this expectation might have brought a general rise in the standard of living, but it also led to more clearly defined social boundaries and to an increasingly uneven distribution of wealth.[149]

The rise of commercial enterprises began to erode the level playing field that had existed when all, or most, relied on farming and working the land to sustain themselves. The businesses that arrived continued to support the farming and lumbering industries for decades, but there was a growing upper middle class with an appetite for the lifestyles seen in Toronto and Montreal. The need for grander and more glorified homes can be seen in the constructs of the North Ward. Orillia began to feel the creep of the social elite.

Economic Twists

The first stages of the Northern Railroad were essentially completed by 1857. The Belle Ewart branch served the passenger, lumber and freight business to Orillia via connection with lake steamers.[150]

"With a view of controlling the navigation of Lake Simcoe, the Directors [of the Northern Railroad] purchased the steamer Morning and the wharves at Orillia and Bradford [Holland River], and afterwards built the steamer J.C. Morrison."[151] In 1855, Northern Railroad's *J.C. Morrison* made the trial trip between the Bell Ewart station and Orillia.

Steamers made the process of travelling from Holland Landing much more convenient than the canoe or bateaux. The heyday of the lake steamers was from 1840 to 1880, after which the railroads took over the passenger and freight business. The dredging of the channel between Lakes Couchiching and Simcoe was proposed and completed so that larger steamers could reach the shallower lake. The *Ida Burton* was the last passenger boat that plied the lake between Barrie and Orillia, beginning in the latter part of the 1860s and continuing until it was "elbowed out" by the railway.[152]

Between 1857 and 1870, there was little done to expand rail services. A serious economic downturn strangled Canada from about 1857 to 1865. There were numerous causes, including a financial collapse in the United States and changes in British tariffs. Additional pressure was brought on Canadians by a drop in grain prices, debt payment deadlines from railroad expansion and over-speculation. (Sound familiar?) In any event, the economic downturn slowed most industry. Orillia businesses did not show a marked increase until 1870–71. This corresponds with the arrival of the railroad and the return of general economic prosperity, demonstrated by the number of Orillia businesses that started in 1870–72.

One side effect of this bad economy was the enlistment by young, unemployed Canadian men in the United States during that country's Civil War. Between thirty-three thousand and fifty-five thousand men from British North America (Canada) served in the Union army, while a few hundred joined the Confederate army. One such enlistment was Charles J. Gill from Orillia, younger son of Jacob Gill. He enlisted in the 151st New York Regiment and served the Union throughout the war. He is buried at the St. James Cemetery in Orillia: "Gill, Charles, Lieutenant, 151st New York Infantry. Born in Coldwater, Ontario, on December 17, 1837. Died February 25, 1916. Buried in Orillia, Ontario. Enlisted as corporal in 1864, fought in Wilderness and Cold Harbor to Opequon (end) and left as Lieutenant."[153] It is possible that other Orillia, Oro and Medonte sons joined in the Civil War.

The changing economy brought back railroad construction. What became the Midland Railroad was chartered in 1846, but tracks were not laid until 1857, when the line from Port Hope to Lindsay opened, primarily as a lumber transport. This line was extended in 1871 to Beaverton on Lake Simcoe and completed a route through Rama and Mara to Midland. It crossed at the Narrows and served Orillia as of 1872. The Grand Trunk (GTR) line to Barrie was extended to service Orillia in 1871.

Two distinct stations in Orillia (Northern/Grand Trunk, Midland) serve to illustrate the disjointed manner in which critical rail service was established in the newly incorporated and growing town. The Midland terminal became part of the Canadian Pacific Railway (CPR) and is now the Legion. The GTR terminal also became CPR and is now the Orillia Information Centre.

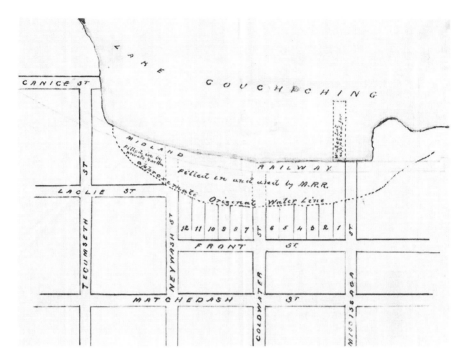

Gerald Alley Street (aka "Front Street") fronted on the water until Midland Railroad added fill to run tracks. Half of the current Metro supermarket would be under water. *OMAH Collection.*

Orillia leaders wanted railways in order to ship lumber and other products out to bigger markets south and east. Railroads received a bonus from towns to defray the cost of building the road. Competition between the Midland Line and the Northern Line intensified in 1871 as they closed in on Orillia. A rushed petition from residents pushed the vote through Orillia Council to give a $12,500 bonus to the Northern in January 1871. Midland had to wait another year.[154]

The Northern Railroad (then the Grand Trunk) line to Orillia was completed in 1871; crossed the Narrows between Lakes Simcoe and Couchiching at Atherley; reached Washago in 1873, Severn in 1874 and Gravenhurst in late 1875; and was at Muskoka Wharf in 1876 to open up the Muskokas to a new era of holiday resorts. The rails were rivals to the services of the lake steamers for freight and passengers. They were building resorts as well, the Couchiching Point Hotel being one. It was

built in 1871 and burned in 1873, never to be rebuilt. The members of the board of directors, however, kept the lavish personal cottages they had been given on the point.

The Midland Railroad had constructed a raised roadbed across the waterfront by 1872, cutting off existing boathouse access to Lake Couchiching. In allowing Midland to bypass the Northern Rail tracks, the council required them to build new boathouses. The waterfront was filled in by 1885 to create what is seen today. Much of what were roadbeds for the railroad lines serving Orillia are now walking and biking paths. On occasion, when a moose wanders onto these trails, one is reminded of Orillia's pioneer days.

The railroads came. Business flourished. The population of Orillia soared.

Chapter 8
THE HEYDAYS

J.L. Tipping & Co., Dealers in Choice Family Groceries, Provisions, Canned Goods, Oysters, Foreign and Domestic Fruits, etc. The Choicest Brands of Cigars and Tobaccos always in Stock —at the sign of the Golden Beaver, Bixby's Gazette, *1887*

Millwrights did not build alone, bakers did not do all of the baking and foundries had to have work crews. Businesses and industry had a crew of workers, skilled and unskilled. Building contractors would have employed masons, labourers and carpenters. Groceries had clerks and teamsters to pick up and deliver produce. Dairies had production crews and delivery staff. Orillia city leaders did not build the town alone.

Millwrights would have subcontracted to a metal smith, like William Tudhope or Robert Brammer, to complete links, nails, brackets, bands and any other metal objects required. Leather workers would provide the wide-band belts used to connect the various working parts of the mill with the drive shaft (water or steam powered). In building the new steam-powered mills, they would have had to have members of the new trades of plumber and steamfitter.

Some were hired help. Of these, a good many were young, unmarried individuals (men or women) learning a trade while awaiting a better opportunity. In other cases, men took on long-term jobs to pay the bills and feed their families. Work was seasonal in the lumber, fishing and tourism industries. Work in the trades and the larger companies was

E. Long and Company remained a major employer in Orillia for decades with a large facility at Queen and West Streets. *OMAH Collection.*

3-PASSENGER INSIDE-CONTROL COUPE MODEL

LIGHT DELIVERY MODEL, CAPACITY 1,000 LBS.

5-PASSENGER STANDARD TOURING MODEL

Tudhope automobiles: a "full" line of vehicles for the 1911 model year. *OMAH Collection.*

regular and paid reasonably well. Much like today, people took work where they could get it.

E. Long manufacturing, Fahralloy, Tudhope Carriage Works, and Canada Wood Products are good examples of long-term Orillia employers. E. Long had upwards of six hundred employees at one point. In 1909, the company moved to a new plant at West and Queen Streets, joining the numerous manufacturers setting up along West Street South.

Tudhope's carriage company employed numbers of workers building fine carriages and automobile bodies. The company introduced its own automobile in 1907. By 1911, it had a line of motor vehicles that rivalled those coming from Detroit. But for the lack of a dealer-based marketing network, the Tudhope-Everitt automobile would have been Canada's own.

All of these people needed a place to live. Many needed homes in which to raise a family. The growth of industry spurred further growth in the building trades and in commercial enterprise. Tract housing started as homes provided for the hundreds of workers who arrived to work the mills and businesses. There were a number of families who made out very well in the process.

Orillia was in its heyday of commercial and industrial power by 1880. Reports from Toronto and as far away as New York referred to Orillia as the hub of Central Ontario—a place for business and pleasure. No longer was Orillia referred to in terms usually reserved for Hades. Railroad fliers and pamphlets described Orillia as a place to come for fresh air and healthy living. There were (and are) a number of summer and seasonal camps on the Couchiching and Simcoe shores. Locals had already found the lure of the lakes and woods, but it was the city folk who drove tourism to the significance it has today. Only a few Orillia or Barrie families could afford to build summer cottages. Instead, the sunny beaches and shadowed bays were enjoyed mainly by well-to-do families from Buffalo, Detroit, Rochester, New York, Cleveland and Toronto.[155]

Visitors to Orillia included Glenn Gould, whose family had a cottage in Atherley, and F. Scott Fitzgerald, whose family sent him to Camp Chatham. His letter home is often taken to mean he hated life in Mariposa. However, reading that his mother was overprotective and stifling to a fault, one can imagine a budding writer's creative way to keep mother at bay:

Dear Mother, I received your letter this morning and though I would like very much to have you up here I don't think you would like it as you know no one hear except Mrs. Upton and she is busy most of the time. I don't think you would like the accommodations as it is only a small town and no good hotels. There are some very nice boarding houses but about the only fare is lamb and beef. Please send me a dollar because there are a lot of little odds and ends I need. I will spend it carefully. All the other boys have pocket money besides their regular allowance.

Your loving son,
Scott Fitzgerald[156]

Housing for workers brought about construction along Front Street, as well as on the former Moffat and Gill Farms. In some cases, people owned their homes, but most rented or lived as boarders. There was little commuting, as most people walked to their eleven- to twelve-hour-a-day jobs. Many of these homes have been abandoned by absentee landlords and are slated for demolition.

Housing also expanded in the northern section of town but for the well-to-do and the new upper middle class. Borland, Brant, Tecumseth, North Matchedash and North Peter Street became fashionable neighbourhoods of fine homes. Many remain today in various stages of renovation and repair and can be seen in Su Murdoch's *Beautiful Old Orillia*.

There was a major shift in building development in about 1880. Some of this was not a result of town planning but rather of a major fire in 1879. The fire destroyed much of the downtown area, which had been built of wood-frame construction. Thirty buildings were destroyed, mostly in the section from Mississauga to Colborne.

In 1872, the reeve (mayor) and council had awarded Robert Pace and William Todd a franchise to build a reservoir in what is now Victoria Park, using the waters of the spring there. Wooden pipes, made of hemlock with the bark still on and joined by iron couplings, conducted the water by gravity from the park eastward, down the

Opposite, top: These cookie-cutter homes along Front Street were to house the influx of workers. They predate housing developments from the 1950s to the 1980s. *Photo by author.*

Opposite, bottom: This well-known image of Mississauga Street shows the town in about 1865. Orillia resembled Dawson City. *Vick Fonds, OMAH Collection.*

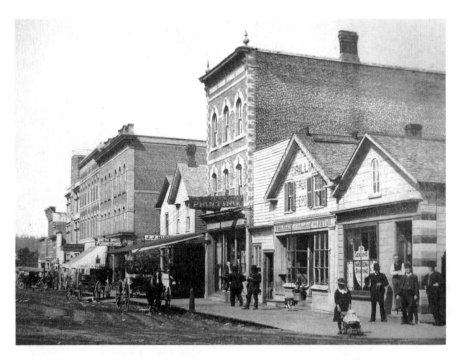

Orillia in 1874. Ten years later, this view shows the changes resulting from the railroad and economic growth. *OMAH Collection.*

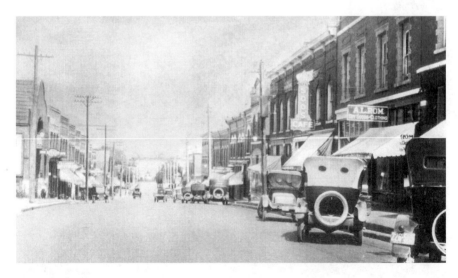

West from Peter, circa 1928. Not only automobiles but also telephone and power wires have entered the scene. *OMAH Collection.*

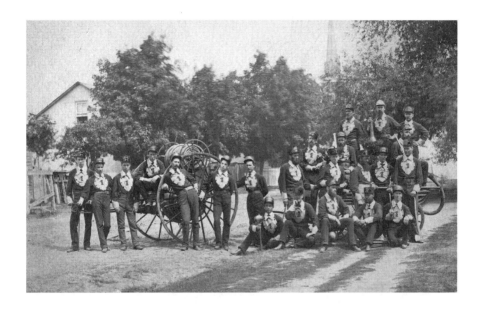

Above: The fire brigade prepares for a parade. The hand-drawn hose reels and hand pumps were no match for the fire of 1879. *Below*: The fire brigade also got some upgraded equipment. Then, as now, fire "engines" were a fascination for youngsters. *OMAH Collection.*

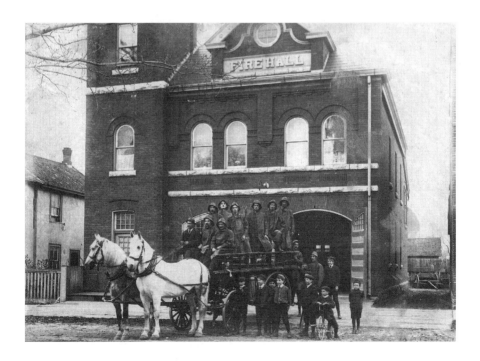

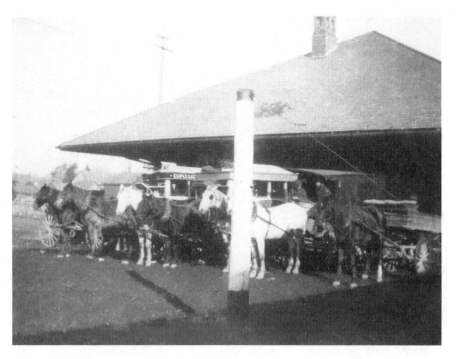

The year 1880's version of the "airport shuttle." Guests were brought to their hotels by horse-drawn "buses." *OMAH Collection.*

main street, with large cisterns at the corners of West, Peter and Matchedash Streets.[157]

Fire took an increasing toll on an ever-expanding Orillia. By 1879, the water available through the existing cisterns was insufficient for fighting fires. Finally, an eight-inch cast-iron pipe was laid from Fitton's Springs to the bottom of Jarvis Street, just west of the former "Club Pavilion," where storage tanks and a steam pumping plant were built.[158] In 1875, the council bought a lot on Peter Street and built a fire hall. In 1896, it rebuilt the hall with a bell tower. It still stands, though as an office building. Fire service has long since become state of the art in the city.

This blip in development did not slow the growth of Ontario's Sunshine City. The railroads saw to that. The rapid development that followed Orillia's integration into the burgeoning railroad network of Central Ontario saw the town grow to 2,186 inhabitants by 1875. The Couchiching Point Hotel was no more, but there were other places in

which to rest after a long trip. By the early 1880s, Orillia boasted six hotels; the town had established itself as a major attraction for "pleasure-seekers" from south-central Ontario.[159] It was nothing to see a series of debutantes heading for one or another of the lavish summer soirées hosted by the resorts and inns—certain to snag a wealthy patron.

LIGHT IT UP

By 1900, the leadership had begun to think about power. Electricity was the key to further growth. Discussions had been going on for several years concerning the feasibility of converting from the existing steam-driven generators to hydroelectric power. As early as 1889, the Orillia Council had been considering the possibility of selling electrical power to Gravenhurst at the price of $1,000 per year for one hundred horsepower, if and when the town constructed a power station at Ragged Rapids.[160] Transmission of power nineteen miles from generating station to end-users was unheard of at the time.

Ragged Rapids Dam lasted only a few years, but sending power eighteen miles from it to Orillia was a first. *OMAH Collection.*

The opera house (right) and Carnegie Library were the crowning achievements of Orillia in the early twentieth century. *OMAH Collection.*

In 1901, the administration building and substation were built in town at 25 West Street North, and the following year, on January 21, 1902, electric power reached Orillia from Ragged Rapids, which thus became the first municipally owned hydraulic plant for the long-distance transmission of electric current on this continent.[161]

A town could offer lucrative rates to lure a business, and the business would be assured of regular service. The electricity served not only industry but also residences, hotels and recreational activity. However, service was still unreliable. In 1904, the Ragged Rapids Dam burst, and power stopped. In 1907, the power was cut off again when the dam failed. By 1913, Orillia had located a new dam at Swift Rapids on the Severn River that stands to the present day. Orillia was not linked to the provincial grid until 1950.

Electricity converted the opera house into a showplace. It originally served as the town hall, lockup and theatre. The auditorium on the second floor was a venue for acts from around the world. The first floor (now the Green Room) held the clerk offices and led to the

council chambers (now the small auditorium). The cells are still in the basement.

There were large companies that employed as many as one hundred workers or even more—E. Long, Canada Wood and Tudhope come to mind. But for the most part, manufacturing was small scale by the standards seen during and after the world wars.

Canada Wood was a stable Orillia Industry for more than one hundred years. It was located from the foot of Colborne Street to the turn at Laclie Street. Before closing in 2008, Canada Wood employed many skilled workmen through good times and bad. It was not the highest-paying industry in Orillia, but it seldom had any layoffs. Many people worked there for years and were able to obtain credit from local banks to purchase homes and cars because of the stable working environment it provided.

This steady work was a facet of life in Orillia from at least 1870 through to the Great Depression (with bumps along the way). Employers, although perhaps not benevolent, at least understood the concept of paying wages such that their employees could afford to buy the products they made. This was also a period that saw long-term, family-owned businesses as the predominant employers in the town.

It was the period when Orillia developed as a city, although that designation was a few decades away. Orillia surpassed Barrie in employment opportunities and commerce. Shipping and tourism combined to build a stable economic base from which to launch other enterprises and projects. In a rare show of cooperation, those who built the city set aside political and philosophical differences long enough to build its legacies.

Chapter 9
WE DEFINE OURSELVES

Don't worry about us, we are having a first rate trip at the Government's expense.
—Leslie Frost, 1915

Duty Bound

Militias have always been a facet of life in any British-based colonial community in the world. This was true of Orillia as well. Twenty-six officers and men of the militia company of Orillia were called up for the Mackenzie Rebellion (1837–38). The list of members reads like a who's who of the town, including Captain J. Drinkwater and Lieutenants Paul Darling and William Fraser. Alongside this group of white militiamen walked the volunteer warriors of Rama. This incorporated militia, part of the Simcoe County Battalion, waited for action at Holland Landing and then again at Newmarket. They went hungry (someone had forgotten to arrange food) and went home.

The Simcoe Foresters originated in Barrie in September 1866, when the 35th Simcoe Battalion of Infantry was authorized. Company 7 was formed in 1866 in Orillia and was included when the 35th Battalion mobilized four companies for active service in April 1885. The York and Simcoe Provisional Battalion was part of the Alberta column of the North

A Brief History of Orillia

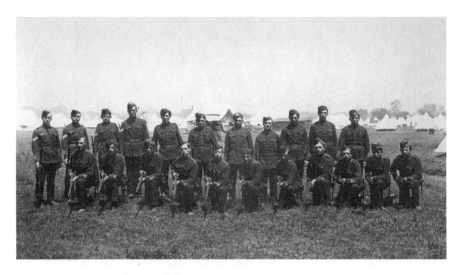

This group is believed to have been part of the Orillia Company of the 35th Simcoe Foresters in about 1900 based on uniform and cap badges. *OMAH Collection.*

West Field Force during the Riel Rebellion. The Orillia Militia Company was sent west for the Riel Rebellion under Captain T.H. Drinkwater, son of the captain who led it during the Mackenzie Rebellion.

The 177th Simcoe Foresters Battalion was a unit in the Canadian Expeditionary Force raised during World War I from the 35th Simcoe Foresters. The regiment saw action in World War I, but as replacement for other Canadian units, meaning the men did not generally fight with their comrades from training.[162]

Leslie Frost was one of those who enlisted for the Great War. He was the son of jeweller William Frost and grandson of John Frost, a baker initially employed by George Vick. He was also premier of Ontario for several years, earning the nickname "Old Man Ontario." In the spring of 1915, Leslie enlisted as a provisional lieutenant with the Simcoe Foresters, the 177th Battalion, and in August, he set off for Niagara-on-the-Lake for training. His brother, Cecil, joined him later at newly established Camp Borden:

> *We roll out here at 5:30 and have coffee & rolls and parade at 6:15 when we have physical drill at 9:00 & have drill till 12:00 then a lecture till one and luncheon at 1:15 then from 2 till 2:45 we have company drill then we are free. We certainly get great meals. For tea*

(dinner they call it here) we had soup and fish, stuffed lamb, thimble berries, ice cream, fruit cake, oranges, bananas, apples and coffee. That's not starvation rations.[163]

Of course, one famous military son adopted by Orillia served in a number of capacities during the early period. Samuel Steele, though a member of one of the original families in Medonte Township, has always been paired with Orillia history. Following his family's military tradition, Steele joined the military during the Fenian raids in 1866. Steele also participated in the Red River Expedition in 1870.

Steele then signed on as one of the original Northwest Mounted Police in 1873, eventually becoming superintendent. (He was somewhat loosely portrayed in the recent miniseries *Klondike*.) He served in the Boer War and in World War I. His family estate, Purbrook, is mentioned by Hester Ann Gill and Reverend Hale as a point of light in the wilderness. The Orillia Museum of Art and History resides in the old customhouse, which was named the Sir Sam Steele Building in his honour. This red brick and limestone clock tower building served as a federal customhouse and post office from 1894 to 1956. The building was purchased by the City of Orillia in 1956.

Many native soldiers returned from the "War to End All Wars" hoping that their sacrifice and achievements on the battlefield would lead to greater recognition and improved living conditions at home. Federal policy extended many postwar benefits to Aboriginal veterans, but not as many as those accorded to non-Aboriginals. Nor did the war herald a broader breakthrough in civil liberties for First Nations soldiers. Many returned to the same depressed economy and demoralizing life that they had left. They still could not vote or purchase alcohol. Their children had limited opportunity and were still shuffled off to residential schools to be "civilized." But as with many who go off to war, their worldview had begun to change.

One of Orillia's lesser-known veterans was an unassuming Chinese Canadian man by the name of Walter H. Louie. Born Wee Hong Louie in 1894 in Kamloops, British Columbia, his father was a rancher who died when Louie was eleven years old. As a young man, Louie worked as a stationary fireman and lived in Shuswap before joining the Canadian Expeditionary Force in April 1917. He served as a gunner in France and later worked as a wireless operator and driver for VIPs, where he learned radio repair. In May 1919, he was discharged and, like many Canadian

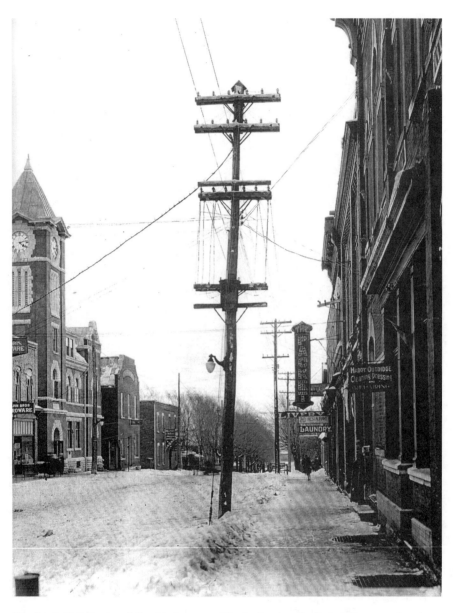

The Steele Building is at left, with the tower. The barbershop in the building next door (now the RBC lot) was one of many gossip stops in town. *OMAH Collection.*

Opposite: Walter Louie, as a member of the 1944–45 Orillia Curling Club champion team. *Photo by author.*

veterans, determined to improve his lot.[164]

After attending university in the United States and receiving a degree in electrical technology, Louie decided to settle in Orillia. He purchased a building and applied for a business license (and possibly a loan as well) to open the West End Radio Shop. He was refused, reportedly because he was Chinese. This appears to be corroborated by his reaction. He shipped his army uniform and medals to Prime Minister Mackenzie King in protest.[165]

The items were returned with a letter from the prime minister purportedly authorizing Louie to operate a business anywhere in Canada.[166] Jack Marshall, longtime editor with the *Orillia Packet and Times*, recalls that his father's first job after moving to Orillia was at Walter Louie's shop on West Mississaga Street.

Walter became well known for his leadership in the Orillia Curling Club and Orillia Gun Club. He employed local youth to pull the clay pigeons for the trap shooting. He was a member of the trophy-winning Orillia curling team in the 1940s and 1950s. Tom Caldwell, himself a champion curler, recalled in an interview that he "learned the new sport, its nuances and its customs under legendary Orillia curlers like Sarjeant, Roy Hewitt, Walter Louie and others."[167] Walter married Orillian Edna Oatway but had no children. He was well accepted in his new home and became a member of the Kiwanis and Canadian Legion, among other organizations.

Soldiers' Memorial

Orillia's first hospitals were the Queen Mary on Dunedin Street and J.P. Secord's Red Cross Hospital on Orchard Point. For many people

then, as today, medical care was an expense not often affordable. The Queen Mary had thirty-five beds. By 1908, it had already become overcrowded and had no acute care facilities. Medical care remained an unaddressed issue for those with little money. Although there was an attempt to cover some services, the Orillia hospital was limited to about thirteen or fourteen long-term beds. Any serious issues had to be dealt with in Barrie.

Victoria Hospital Barrie
Dear Milton

I won't write you much this time as I am very miserable indeed. The Dr. says that I am doing well. But I don't feel much like it. He says I will be up by Saturday. Just imagine the time I have been away from the children. It is not very bright here. It does not seem as if I have much news. Well Milton our expenses are heavy. The operation cost one hundred dollars and hospital expenses about sixty. Rob has come in every Saturday night and stayed till Monday. His expenses of train fare is 90 cents besides his board. Well Milton I must close as I am writing this between spasms of pain that make the perspiration stand out on me. Good by for the present.

Your sister Mag.[168]

This letter never got mailed. Margaret Jane Jones Kendall was taken to the Barrie hospital from Orillia on December 31, 1902, and gave birth to a stillborn child on January 2. She remained in the hospital until she died on March 29, 1903, of complications from an abdominal abscess, the doctor's assurances notwithstanding.

The Red Cross Hospital (no relation to the international organization) opened in 1889 and carries the honour of providing Canada's first medical insurance plan. Conceived as a means to fund services, insurance was sold for five dollars per person in return for in-hospital care for up to a year. The hospital was built on Orchard Point but failed after three years due to flagging sales of insurance certificates.[169] The site of the hospital was that same site where A.F. Hunter had located Ojibwe burials and evidence of a village. It was the same site that had been a rendezvous setting and sacred place for natives for more than two thousand years and the site of the early Orillia fur trading posts.

The Orillia Soldiers' Memorial Hospital was completed in 1922, in large part due to the editorial and oratorical efforts of C.H. Hale. *OMAH Collection.*

After the Red Cross Hospital closed, it was turned into the Orchard Point Inn, which burned down in 1956. Currently, there is a condominium project located at a site that certainly has seen its share of visitors over the centuries.

Still, the concept of building a hospital that was affordable would not die. Orillia's efforts continued to presage Canada's healthcare system. The consequences of World War I gave rise to another project. A legacy of the war was the sheer enormity of the carnage. For example, at the Second Battle of Ypres, the Canadian Division alone suffered more than five thousand killed and three thousand wounded or missing.[170] Returning soldiers had limited veterans' benefits and care. Many simply returned home to succumb to wounds, mental and physical. Many soldiers required long periods of recovery and lived with disabilities thereafter. Although not unusual for postwar periods, the number of returning soldiers in need caused serious problems for medical services, as well as towns.

Orillia's C.H. Hale conceived of a hospital for the soldiers returning from war. He and others had witnessed too many in need of care and assistance. There was no systemic, national veterans' care program at the time, so Hale worked with a committee to develop what is now the Soldiers' Memorial Hospital. The new hospital was completed in 1922

and offered a unique service: free care to veterans from all over Canada. Veterans from as far away as Newfoundland came for treatment and assistance in the days before veterans' benefits.[171]

Orillia has also set up a cenotaph at the Soldiers' Memorial Hospital on Colborne Street. It honours Orillians who have served Canada since 1914. Since 1996, on Remembrance Day, the local Cadet Corps posts a silent guard overnight.

Another outcome of the conflict was the formation of the Dumbbells. The comedy troupe, led by Orillians Merton, Albert and Morely Plunkett, served to entertain and amuse the troops. After the war, the players continued to provide shows in England and the United States. The troupe embodied a tradition of theatre and music that Orillia holds to the present day.

It is important to recall that there were about eight thousand residents in Orillia and area (Oro, Medonte, Atherley and Rama) and that at least one thousand of these had enlisted. There was a shortage on the farms as well as in the factories. While the "boys" were at war, the town encouraged the growth of what were termed "Victory Gardens" in the United States. Local patches of ground became gardens, and everyone pitched in. The board of trade urged factories to release workers to help in seeding and harvesting.[172] This movement has gained renewed attention in the early twenty-first century with the concept of "community gardens" and local sourcing.

SCHEMERS, PROHIBITION AND TUNNELS

Thomas Williams opened the Orillia Brewery in 1871 at Brewery Bay. Some say that this is one reason Stephen Leacock chose the site for his summer home. Henry Fairall (or Fairhall) arrived from the Isle of Wight in 1881 and constructed the town's second brewery, the Orillia Brewing and Malting Company, at the corner of Mississauga and Andrew Streets in 1882. Fairall brought in a partner, Melville Herbert, in 1882 and then sold the business in 1883.

The liquor ban under the local option legislation took place in 1874 and shut down the bars and shops selling liquor. Despite this, a second brewery opened in 1883 on Mississauga Street. Fairall and Herbert found a novel way to skirt the local option law.

The law made it illegal to sell beer in Orillia, but it was not illegal to buy beer outside town and have it delivered into town. The Orillia Brewery Company at Mississauga and Andrew Streets found a way to obey the law and still stay in business. Every morning, the brewer loaded up his wagon and took the beer to a warehouse on the fourth concession of the old Orillia Township. The warehouse was a small shack with a door in the front and a door in the back. The driver unloaded the beer in the front door and took the wagon to the back door. There he reloaded the beer and returned to town. That beer, having been delivered from outside of town, was perfectly legal.[173]

This liquor ban was declared invalid by the courts in 1906, but temperance forces rallied and managed to get the town council to pass another local option bylaw banning the sale of alcohol in the town limits. After a heated session, completed behind closed doors, the law passed. The following year, the voters shut down all of the bars and taverns as well. Orillia was (officially) dry.

The shenanigans of the politicians and business elite in Orillia gave fodder to the humorous anecdotes written by Stephen Leacock. Well known around the city is his *Sunshine Sketches of a Little Town*. Mariposa, the town he speaks of, has become the nom de plume for Orillia and events related to Orillia. Initially irritated by the caricatures in the book, Orillians have grown to accept the eccentricities and foibles of the characters as part of their heritage, and with good reason. The list of eccentricity bears a little discussion. Thanks to Randy Richmond for collapsing much of this from news stories.[174]

DAYLIGHT SAVINGS: In 1912, Mayor William Frost adopted the idea of C.H. Hale (of the *Packet*) to set clocks back for the summer, allowing an extra hour of light at the end of the workday. When it was implemented as a trial, most people (including the mayor) botched schedules and workdays so badly that there was clamour for it to end after only two weeks. Still, it was an Orillia "first." It wasn't the only time C.H. Hale pushed to make Orillia stand out from among the small towns of Ontario. Ten years later, as noted earlier, he led the push for Soldiers' Memorial Hospital.

ORILLIA SCRIP: Ben Johnson spent most of his career in a long feud with the city council, including one over his Depression-busting project. Mayor Johnson, about whom there is enough to fill another book, thought that the idea of printing his own money made sense. After all, Kitchener, Ontario, had been doing this for some time. Ben had the scrip printed

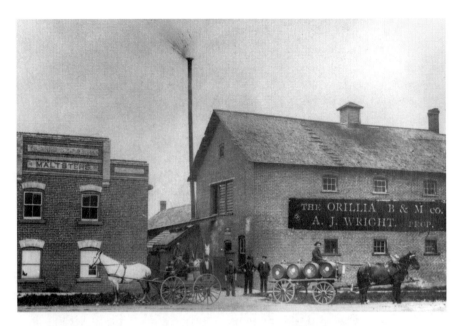

This was Fairall and Herbert's brewery at the corner of Mississauga and Andrew. *OMAH Collection.*

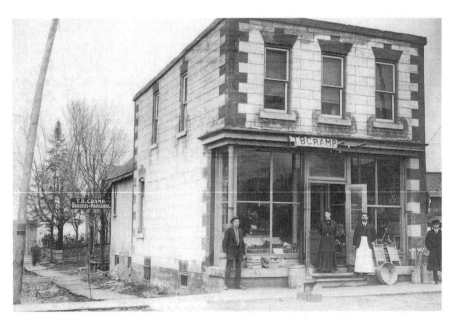

Next to Herbert's brewery stood the dry goods and feed store of T.B. Cramp, father of one of Orillia's more colorful characters. *OMAH Collection.*

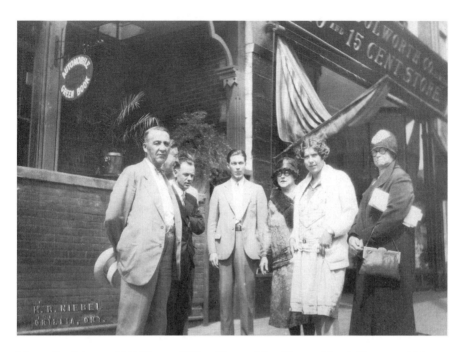

Mayor Ben Johnson, Skid Watson, Wilbur Cramp, Mrs. Watson, Mamie Shrum and Mrs. Leach. *OMAH Collection.*

and distributed, with a percentage returned to the city as revenue. Ben truly wanted to make the lot of the poor man better—and his own as well. In 1936—one of his several single-year terms as mayor—Johnson was accused (not without reason) of drinking with bootleggers and running up his expense account on personal business. He was only one in a long list of mayors who could provide additional fodder for another Leacock.

HIZONER THE MAYOR: Wilbur Cramp, son of T.B. Cramp, carried on his father's feed business. But Wilbur had an appetite for publicity and the public eye. In the books, Wilbur has had the reputation of being somewhat of a lush. Having managed to rent the building next to his feed store to the first liquor establishment at the end of prohibition, he proceeded to make withdrawals as needed. Of course, he left an IOU for each bottle and paid up in full.[175]

Wilbur was a character of varying repute, yet he was apparently there for his friends. One of these was Irvine Douglas, chief of the Chippewas of Rama during the 1960s. When Irvine, a World War II veteran, applied for a business loan, he was informed that he needed a cosigner. Irvine

got Wilbur to back him for the loan, based on a long-term relationship between the two.[176] Unfortunately, Irvine was native. Despite (or perhaps because of) obtaining the mayor's signature, Irvine was turned down by the bank. He had his revenge several years later.

THE BOYD HORSE: In June 1904, Moses Boyd took over the old Hoy Harness Business located at 98 Mississauga Street East. He also inherited the Hoy (now Boyd) Horse. The Boyd Horse was seventeen hands high and 750 pounds of solid wood covered in burlap. Used to display the many harnesses, saddles and collars produced in the shop, it was a fixture along Mississauga Street well into the 1970s.[177]

THE OPERA HOUSE, PROHIBITION AND TUNNELS: The opera house is the embodiment of Orillia and its greatest landmark. Built in 1895, it served as city hall, concert hall and market. The basement once housed the local jail cells and the entrance to what has been called a tunnel. Now bricked over, legend has it that the tunnel ran from the former city hall location to the present location of the former Fred's Meat Market, where locals could allegedly find spirits during prohibition. These tunnels have entered the conventional wisdom of Orillia despite no real rationale or evidence. Besides, the opera house is not across from the brewery and would call for a diagonal tunnel of some length—and cost—under Mississauga Street. Based on tradition, construction of a tunnel would have required at least a decade of discussion and several consultant studies. By that time, prohibition would have been over.

Fred's is at the location of Herbert's brewery, which is the only apparent connection to this local supposition. There is no documentation to prove the purpose for the tunnels, of which entrances lie under Fred's (a former brewery), Brewery Bay (the former Shangri-La) and Mariposa Market (the former Vick's grocery). Most of the alleged tunnels are located under or in the vicinity of such retail businesses or other places as would have routinely kept stocks of perishable items.

Given the climate, it would be virtually impossible for a grocer to store produce or fruit, or a brewer to store hops and grain or sprout malt, in an open barn or storage shed. The business would be lost after the first frost. Yet the cost of heating a barn or outbuilding for this purpose would have been viewed as insanely extravagant. The solution, it would seem, would be to have the same sort of facility used by the average housewife and farmer: a cold cellar. This purpose for the "tunnels" appears to be more in standing with the conditions and needs of a time before heating and refrigeration than for the transport of illegal hooch.

During prohibition (which lasted more than seventy years in Orillia), there was ample opportunity to obtain alcohol within an easy drive of West and Mississauga Streets. There was no need for politicians or others to go to extreme lengths to obtain a drink.

Temperance remained a public issue in Orillia long after the shantymen and navvies had left. Nevertheless, quiet evenings sipping lemonade and summer strolls along the streets of Leacock's Mariposa were not the only gambits enjoyed by Orillians. Entertainments at local homes attracted regular attendance by many of the elite, complete with adequate amounts of liquid refreshment. Obtaining this refreshment was no more difficult than sending the chauffeur across the Narrows bridge to what was then Ontario County.

The Atherley Arms Hotel sits empty at the end of the Narrows bridge. The establishment could sell alcohol since it was outside Orillia. It was the first place heading south on Highway 12 where one could purchase alcohol, hence the nickname "The First."[178] The hotel provided guests with live music and ten-cent beer well into the 1960s. However, Aboriginals were not served until well into the 1970s.

The "lower classes" had to work a little harder to get their beer or whiskey; they had to arrange for a walk or drive out of town limits. Stories abound of near fortunes made by cabbies who, upon taking their fares to Barrie, returned with a dram or two "on order." Up to the end, many folks went to "church" for a little "mickey" and perhaps some cards. It has been said, but never proven, that the city council met in closed session on many a night—and tunnels were not needed.

Chapter 10

WORLD WAR AND CHANGE

World War II came as a surprise to some, but not all. The Canadian army found itself with the monstrous task of building an army for its contribution to the imperial war effort. The government had to raise and train recruits and provide the mountains of equipment and material they would need. Orillia sent more than 1,000 of its population of 6,000 off to war. More than 150 never returned.

In 1939, the Permanent Force Army had only 4,261 officers and men. The Non-Permanent Active Militia (the reserve force, including Orillia's company of the Simcoe Foresters) had 51,000 soldiers, but most were only partially trained and all were ill equipped for fighting a war.[179] Army training camps sprang up across the province to upgrade the militia and train fresh recruits. One such was Orillia's Camp 26. It took over the spot where the Orillia Hippodrome had been.

> *This sprawling camp was built on land locally known as the Quinn Farm, roughly bordered by Reynard, Brant, North and Lawrence Streets today, adjacent to the "Oval" and the West Street Armoury, which itself dates back to September 1913, just prior to World War I.*[180]
>
> *…Throughout the war, the camp went through several name changes: No. 26 Canadian Armoured Corps (Basic) Training Centre (1943–44), No. 26 Canadian Infantry (Basic) Training Centre (1944–45) and, finally, the 13th Infantry Training Battalion (1945–46).*

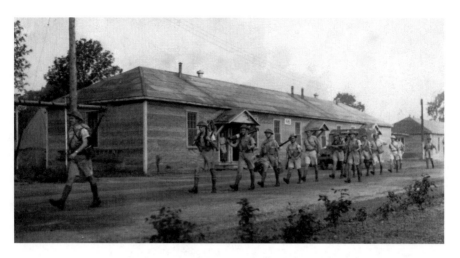

Orillia's army camp, officially designated as No. 26 Canadian Army (Basic) Training Centre, opened in April 1942.

View of the parade ground from the NCO building at Camp 26 in Orillia.

Unofficially, the camp was known as Champlain Barracks. It was closed in 1946, and all forty-two buildings were sold to private interests and either moved or demolished. The barracks, classroom, drill hall and administration buildings have been replaced by tree-lined residential streets, commercial development and schools.[181]

The Maple Leaf Club (part of St. James Parish Hall) was the site of dances and games.

During the operation of Camp 26, Orillians made enormous contributions to the war effort. As with most "army towns," there were conflicts between locals and the soldiers, but these appear to have been minimal. Orillia was still a dry town under the local option. Entertainment, for the most part, consisted of dances, recreation through the various churches and the YMCA and ice cream socials.

The Maple Leaf Club employed many volunteers who would cook and sew and prepare packages for the soldiers. They would also dance on a rotating basis, just like the portrayals in the Hollywood movies. This was a chance to let off some steam or just forget about the week's training. The Orillia Salvation Army and the various churches in town were heavily invested in providing volunteers. The YMCA served much the same purpose for the soldiers as it did for the civilians:

> [The Maple Leaf Club] *was a favourite place for everybody and the women were so great, there were always women there. Well, they didn't do things for the girls very much because the girls could sew. They had sewing machines there that the men could take a jacket in or the sew on buttons and there was always someone that could play a piano and I think it was open, if it wasn't open every night, everyday it was open most of the nights.*[182]

It is always a disturbance when an army comes to town (even a friendly one), but Orillians had many sons in the military as well. To many, the giving of time and assistance to these recruits from other towns was a silent wish that someone was doing the same for their own sons and daughters.

Camp 26 had its contingent of the Canadian Woman's Army Corps (CWAC). Many trained there as support staff and communications specialists. They were then sent to other bases or overseas to perform those functions. Women were not allowed in combat roles until 1989. In 1943, many were also not easily welcomed at local establishments. Evelyn Davis, a CWAC assigned to Camp 26, recalled:

> *The first time I would say maybe four girls went down to Carters Grill, we sat and we sat and I'm just not too sure whether we finally got served or whether they never served us. So we went back and complained to our officer. I don't know what their idea was and so got that all straightened out and by the time I left in March '44 we were all the best of friends, the people down there were making birthday cakes for the girls and it couldn't have been nicer.*[183]

It was not the only entertainment in town. Orillia was small, but the influx of wartime production brought thousands of workers, resulting in hundreds of impromptu boardinghouses and rental flats. The dance pavilions were popular with the soldiers, but with the disproportionate number of women in town, a dance was hard to come by for the CWACs: "I know that down at the lake at the park there was a pavilion at one time, a dance pavilion. We'd go down there and stand and hope that somebody would ask us to dance and hardly anybody ever did."[184]

As with many towns prior to universal refrigeration, there were several dairies operating within Orillia city limits. Most made ice cream as well, selling it locally in small shops. For example, the Orillia Dairy Company at 24 West Street North operated an ice cream bar, as well as a large dairy building and stables located behind the West Street store. It manufactured the Champlain Ice Cream brand. The dairies, ice cream bars and eateries in town were heavily patronized by the soldiers and the workers brought in for the war production.

Evelyn Davis and her fellow CWACs would have found large numbers of women living and working in Orillia. As elsewhere in the world, women were essential to the production lines. Although women were relegated to homemaker status following the return of the veterans, their sole role as homemakers was never fully accepted afterward.

The YMCA operated out of this building on Peter Street before moving to its current location.

OTACO (the continuation of Tudhope Manufacturing) produced undercarriages for Mosquito fighter-bombers. They had extensive experience in metal casting and, by 1939, had 1,600 people working compared to just 11 three years earlier. E. Long Manufacturing produced cartridge casing machinery and shipped it throughout North America.[185] Fahralloy and others produced a variety of military goods, including PIAT (anti-tank) shell casings.

The Hunter Boat Works, at the port, switched to full production of Fairmile Interceptor Boats (similar to Patrol Torpedo Boats), which were used by the Canadian and British navies for a variety of purposes. These were relatively fast and small and could be configured for a variety of tasks. The Fairmile series continued in use by many navies around the world long after the war.

People are still around at this writing who can recall the rigors and challenges of rationing during World War II. Orillians pulled together, as did others in the commonwealth, to support the war effort. The local papers encouraged "War Gardens" (also termed "Victory Gardens"), similar to efforts that had been put into place during World War I.

Left: War production included Orillia's women.

Below: The B Class Fairmile Motor Launch at the Hunter dock, at the foot of Colborne Street.

Recently, there has been a return to "eating locally." Community gardens and local cooperative efforts have begun again in Orillia, although without the level of government support experienced during the war periods.

While rationing was in place, recipes arose to meet the needs for households to feed a family on less. The need for treats was not forgotten. The following recipe appears to float the sweet tooth but just might sink the stomach. We may never again complain about that Christmas fruitcake:

War Cake—Brown Sugar

War cake or boiled raisin cake was a popular cake as it used no butter, milk, sugar or eggs. It could be made with molasses, honey, syrup or brown sugar—depending on what was available. Because it has a long shelf life and was a dense, hardy cake, it was often wrapped up and sent overseas—a journey that could take several months.[186]

Ingredients

1 cup brown sugar
1¼ teaspoons water
⅓ cup shortening
2 cups raisins
2 teaspoons cinnamon
½ teaspoon ground cloves
½ teaspoon ground nutmeg
2 cups flour
1 teaspoon baking soda
1 teaspoon baking powder

Preparation

1. In large pot, combine sugar, water, shortening, raisins, cinnamon, cloves and nutmeg.
2. Boil for 3 minutes.
3. Remove from heat and cool to room temperature.
4. Preheat oven to 350 degrees F.
5. Sift together flour, baking soda and baking powder.
6. Mix flour with raisin mixture.
7. Pour into a greased and floured 8-inch square pan (batter will be stiff).
8. Bake 45 minutes.

Afterward

Like hundreds of towns and cities, Orillia found the need to build homes for the returning servicemen and servicewomen. The army moved all operations to Base Borden, near Angus. The old Camp 26 was dismantled and sold to developers. The homes on Dalton Crescent and those between Brant, Balmoral and Lawrence Park opened for returning veterans and their families. Homes were built in the farm lots off of Westmount Avenue. Developments began on Couchiching Point and Invermara and off Forrest Avenue—supplements to the summer cottages that had been a fixture in those spots for more than one hundred years.

More people owned homes than ever before, fuelling the construction industry. As was true in the early Orillia boom of 1871, various support businesses and services were also needed—including banking, shopping markets, auto repair and servicing and so on. Additional, upgraded schools were needed and built—many of them have since been demolished. Transportation changed with the new, upgraded highways edging out the railroads and bringing a host of cottagers each season. The Trent-Severn Waterway brought boaters in droves, requiring the city to upgrade its port facilities and improve Couchiching Beach Park on the waterfront. A transfer to the city of J.B. Tudhope's Barnfield Point evolved into Orillia Motor Campground and then present-day Tudhope Park. The park hosts thousands of beachgoers annually at a sandy beach constructed with assistance by the Moose Lodge.

Bumper-to-bumper weekend traffic began in the 1950s. Boat traffic increased between 1950 and 1970 from 40,000 to 160,000,[187] and it is even greater today. Lodges and hotels were built, rebuilt and reinvented. The "motor hotel" (motel) was soon in fashion. With so many people owning automobiles and gas rationing a thing of the past, road trips became a regular facet of life. Travel to the northern reaches of Ontario was increasingly done by automobile, motor coach or seaplane—heralding the death of the railroad as the principal means of getting to Orillia. In the summer, the Trent-Severn Waterway brought thousands of tourists into town for a concert or meal.

From the 1960s to the 1980s, the demand for a waterfront cottage far outstripped the traditional "shanty." "Real estate developers bought up miles of lakefront property and divided it into postage stamp–sized lots. Long stretches of overcrowded shoreline looked like

Port of Orillia, circa 1960, including seaplane service, hangars and docks. In 2013, a completely revamped marina was put into place.

suburban streets."[188] Orillia was not missed in this frenzied activity, with apartment projects and shoreline development emerging along the old bays and on the points that once housed grand resorts. The development continues to the present time, with several projects in place, under construction or planned. The seniority of the Orillia population has increased as well. Many people choose to retire here, and high-rise condominiums or retirement homes replace the tall mills of old along the shores and coves.

In the winter, the ice huts dot Lake Couchiching and Lake Simcoe. Of course, that is nothing new. Lake Simcoe has long been recognized for its winter fishing. Even Champlain wrote about the process:

> *They make several round holes in the ice and that through which they are to draw the seine is some five feet long and three feet wide. Then they begin to set their net by this opening; they fasten it to a wooden pole six or seven feet long, and place it under the ice, and pass this pole from hole to hole, where one or two men put their hands through and take hold of the pole to which one end of the net is tied, until they came back to the*

opening five or six feet wide. Then they let the net drop to the bottom by means of certain small stones fastened to the end of it. After it has been to the bottom they draw it up again by main force by its two ends, and thus they bring up the fish that are caught in it. That in brief is the method they use for fishing in winter.[189]

As for the custom of pushing ice huts out onto the lake each winter, Elizabeth Simcoe described it in 1795: "The Indians have cut holes in the ice, over which they spread a blanket on poles, and they sit under the shed, moving a wooden fish hung to a line in the water by way of attracting the living fish, which they spear with great dexterity when they approach."[190]

GETTING HERE

The Great Northern and Midland Railroads opened Orillia to both industry and tourism. When Canadian Pacific consolidated all but a few of the local lines, connections brought people and freight to and from all of North America. But railroads required a lot of traffic and business to sustain themselves. The business started to slip from their fingers. Commerce needed more direct delivery to customers, many of whom were no longer located along rail corridors:

During the period before World War II, there was insufficient demand for the provincial or county governments to develop a large road network. Many people continued to travel by horse and sleigh in the winter months, and most roads were less than passable. It was not until the mid-1930s that provincial highways in Simcoe County and county roads were ploughed for winter use, and it was still later before an attempt was made to keep township roads open.[191]

People simply stayed at home or used one of the tried-and-true methods of travel—snowshoeing, skiing or by sleigh. Horsepower often meant the kind that ran on hay rather than on petrol. In the summer, travel was by rail, steamship, canoe and sail as much as by auto. Cars were not unknown; after all, Tudhope had built them right here in town. Cars were available, but the

road system was not. In this sense, life in Orillia mirrored that in many rural areas of Canada and the United States.

A decade after World War II, with so many families able to afford automobiles, the principal method of getting to and from Orillia was the family car. Once the highways were constructed and improved to meet the needs of the new motoring public, the motor transport industry rapidly increased. Delivery of goods and services directly to the customer started with courier services and consolidation of shipments by transport. Today, it is not unusual to see dozens of transports travelling Highway 11 from farther north—a role formerly left to the rails.

On August 5, 1931, Highway 12 was extended from Orillia to Midland. The majority of the route paralleled an existing railway (Midland) that had been constructed from the Narrows to Matchedash portage. Travel to the north became more convenient for tourists. One still had to drive over the one-lane Narrows swing bridge, through downtown Orillia and up Coldwater Road to reach the new highway. At least it was paved…mostly.

Over the years, Highway 11 grew to stretch from downtown Toronto all the way to the Minnesota border. Highway 11 became synonymous with Yonge Street, which formed its southernmost segment. It is from this link that Yonge Street gained the oft-disputed reputation as the "longest street in the world." For decades, Highway 11 was the principal route to "cottage country." A proliferation of small motels, inns and burger stands within Orillia emerged during this period, similar to the hotels built to serve steamship tourists of the 1860s and railroad travellers of the 1890s.

In 1956, two new bypasses were completed around Orillia. The South Orillia Bypass was constructed as a two-lane highway diversion that began near Atherley Narrows and continued westerly to the Highway 11 Bypass. The Highway 11 Orillia Bypass was built as a four-lane freeway to allow all through traffic on Highway 11 and Highway 12 to bypass Orillia entirely.

After completion of the Orillia Bypass, the old route of Highway 11 through downtown (via Memorial Avenue, Colborne Street, Front Street and Laclie Street) remained as Highway 11B. Laclie, one of the original streets in town, was also known as Muskoka Highway. At times, it is still referred to as Old Muskoka Road. Traffic continued to weave through Orillia until the 1970s.[192]

One reason for Orillia's explosive growth since 1980 is Highway 400. The second-longest freeway in the province, it was the first fully controlled-access highway in Ontario (hence the "400" series). The 400

Highway 12 Bypass construction, 1956. In the far background is Huronia Centre farm.

Pilot error? Perhaps this 1970s tourist thought the LCBO Liquor Store had a "fly-in" window. *OMAH Collection.*

parallels Yonge Street and the old portage trails and serves much the same purpose. Commuters travel in all weather from new subdivisions to Barrie and Toronto. The impact on Orillia was enormous. This highway, plus the widening of highway 11 North from Barrie, finally made Orillia a viable suburb of the Greater Toronto Area.

The tourism trade has produced some incidents that might rival the antics of those shantymen of old. Having a seaplane port so near the downtown certainly had its ups and downs. The port is now at Lake St. John, although planes regularly arrive at the public dock at Couchiching Beach in the summer and fall.

Chapter 11
LEGACIES

*I had an inheritance from my father, it was the moon and the sun.
And though I roam all over the world, the spending of it's never done.*
— *Ernest Hemingway,* For Whom the Bell Tolls

Orillians often express concern over the legacy they will leave. Pages of copy and correspondence address what will be thought of the place in the next century or how Orillia will survive to that century. Council meetings and debates held over a beer at the pub provide more than enough grist to feed rumours and opinions.

Orillia has served as the home for famous and infamous people and industries. Over the years, the city has been held up as both a positive and a negative role model—often at the same time by different camps. If cities and towns develop personalities, much like people, then Orillia's personality would seem to be that of a well-heeled grandparent with a rebellious mind. It has seen it all but yearns for more.

The Hotel that Wasn't

In 1867, the year of the village charter, there were several establishments offering accommodations, including boardinghouses and eating salons.

A view of possibly Neywash Street, circa 1860–65, based on the asylum at the far left and the lack of development. A rider and horse are in the centre. *OMAH Collection.*

By far, the largest and most elegant would have been Henry Fraser's establishment, but he failed in that endeavour. Henry Fraser's Folly led to the founding of one of the longest-running employers in Orillia—one of controversy even to the present day.

Fraser had been running what was loosely termed a "hotel" at Price's Corners for several years. He anticipated the growth of the village but set his sights a bit too high. The first inn was built by 1841, and he was allotted the wharf reaching out to where the water attained a depth of nine feet. He continued to develop plans for a larger hotel. In 1856–57, he began construction of a large brick building, but on too large a scale. He quickly ran out of funds.

The government of Ontario was looking for a new facility to take overflow from the Toronto Asylum. Discussion resulted in plans for stand-alone asylums for "insane" and "mentally deficient" persons. They discovered Fraser's Folly. By October 1859, Fraser had completed sale to the Canadian government, and the Convalescent Lunatic Asylum at Orillia became an established fact. It soon began to undergo enlargement and completion (in 1860) under the superintendent, Dr. John Ardagh, and Kivas Tully of the Public Works Department. The building erected for a hotel became the first asylum in Orillia and a model for others in the province.[193]

At a conference in 1871, Dr. Benjamin Workman, assistant superintendent of the asylum at Toronto, gave figures in reference to overcrowding of institutions for persons with mental illness in Canada. Mental health experts of the time discussed the necessity of providing for what were termed "incurables" in branch asylums with a sufficient staff of attendants and facilities for utilizing their labours. Dr. Workman saw no other way of preventing the lamentable discharge of chronic cases to poorhouses than to provide a cheaper grade of accommodations in connection with a separate institution.[194] In his presentation, he noted an example of the half-finished brick hotel in the village of Orillia. The hotel had been purchased and fitted up, and 132 patients were moved from Toronto.[195]

The asylum was three stories high and heated by steam, and it had, with its two wings, a frontage of 118 feet, the verandahs being railed in with iron rods, giving it a unique appearance. By 1866, the patients numbered 140, and the official title of the institution at that time was the Orillia Lunatic Asylum for Chronic Patients.[196]

Such facilities were typical of the period philosophy in treatment of mental illness and developmental disability. Throughout North America, asylums had replaced prisons as sites for those who had become public wards. Orillia's asylum was just the sort of location sought for these people and was one of the earliest publicly funded facilities on record. It was also out of the public eye, an important element in all of the early institutions.

The asylum was abandoned in 1870 upon the transfer of the patients to a new facility at London, Ontario. The building sat empty until 1876, when the province decided to use the location as an "asylum for idiots." The Orillia Asylum reached full occupancy so quickly that, within two years, the province had to put the overflow of patients in the Queen's Hotel in downtown Orillia. A new facility was developed in 1885 on the shores

The asylum was a fixture at Couchiching Beach Park into the 1890s and can be seen in the background of several photographs. *OMAH Collection.*

of Lake Simcoe, but the old building was in use through to 1886–87, when the new institution was completed. The mound in Couchiching Beach Park, on which runs the mini-railroad, is the footprint of the old asylum.

At the new centre, renamed the Ontario Hospital School, patients were offered manual training and initially worked only on site. At its peak, it housed 2,600 residents, with patients coming from all over Ontario. A special station was built at the centre by the Grand Trunk Railway so residents could be brought to the centre without having to travel through Orillia.

For the most part, the province sought self-sufficiency for the facility and the patients. Educational philosophy at the time assured the public that the most residents of such places could become self-supporting within the confines of the institution. Experience proved this woefully inaccurate.

In 1916, the same Dr. Benjamin Workman noted, "As to the question of the profit to be derived from the labour of chronic insane patients… while such labour is valuable, especially in farming operations wherever an auxiliary is established, it cannot be made so profitable as to render

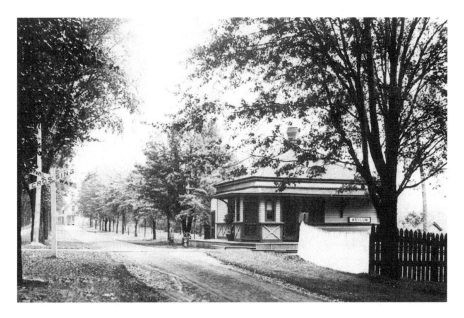

Asylum Station, located at mile 84.2 from Union Station, Toronto, where residents arrived and some departed. *OMAH Collection.*

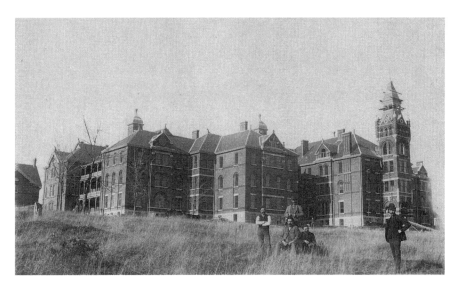

Ontario Hospital School in about 1920. Its farm and graveyard were across what was then Highway 11, where the Ontario Provincial Police (OPP) headquarters is now.

the institution self-supporting since whatever work is done must be done under certain disadvantages, and necessitates the supervision of experienced persons. [However,] the form of labour which he considered most desirable is that upon a farm."[197]

In 1960, Pierre Burton, the renowned historian and expositor of all things Canadian, happened to come to Huronia Centre with a friend. He wrote a scathing report for the *Toronto Star*. In it, Burton enumerated the political and social neglect that had left the outnumbered staff responsible for an overcrowded and crumbling facility. His allegory was directed at all Canadians, as Huronia Centre was no better or worse than many such facilities: "Orillia's real problem is one of public neglect. It is easier to appropriate funds for spectacular public projects, such as highways and airports, than for living space for tiny tots with clouded minds. Do not blame the present Department of Health for Orillia's condition. Blame yourself."[198]

One of the former residents recalled being "farmed out" to a local mink farm. "I did not like it much. They [the minks] bit me and my friend. The people treated us bad. I don't want to go back there."[199] Despite individual stories of abuse and neglect, the vast majority of HRC workers were conscientious and dedicated. They performed tasks no one else wanted to do and made the best of a difficult situation.

The Huronia Regional Centre (HRC) was one of Orillia's largest employers. It was closed in 2009, and many employees retired or transferred to work for other government organizations. Many of the former residents remain in Orillia and, if not pointed out, would not be noticed as they go about their daily business. There were thousands of residents placed in and around Orillia. In a return to what had been hoped for by the founders of HRC, most are doing just fine, and the community has accepted their presence as part of the "norm."

On September 17, 2013, the Ontario government agreed to a settlement of $35 million and an official apology to the survivors of Huronia Regional Centre. Because of financial agreements signed when they entered the facility, many former residents will never see the funds. Most feel that the apology is a day late and a dollar short.

Currently, there are no people with developmental disabilities living in large institutions in Ontario. This is the first province to have closed all of its large, congregate facilities. Fraser's Folly had come full circle after 130 years.

Musical and Artistic Legacies

In Orillia, you hear often of Stephen Leacock, Arthur Shilling and Franklin Carmichael. There is the music and artistry of Gordon Lightfoot, Glenn Gould and Lance Anderson. Sculptors, painters, musicians, actors…Orillia has hosted them all over the years.

Of course, the character most associated with "characters" in Orillia is Stephen Leacock. Orillians rightly focus on Leacock's *Sunshine Sketches of a Little Town*, but Leacock made his mark in economics and conservative political humanism while teaching at McGill University. His *Elements of Political Science* sold millions of copies in nineteen languages and, with his satires and commentaries, supported his lifestyle into retirement. That lifestyle included fishing, sailing and gardening in Orillia.[200]

The reaction to *Sunshine Sketches* by Orillians has always been mixed. The name of the fictional town, Mariposa, finds its way into every nook of the town. Yet Leacock's portrayal of a place striving to be more than it might ever achieve lingers. In analyzing the work—and there is a litany of microscopic dissections—there is always the tendency to accept the quaint and avoid the less charming. What is certain is that Leacock the person had an intense impact on Orillia, and the town gave him sufficient fodder to do so.

The manuscript of the 1912 book and a collection of Leacock's papers are held in his summer home—now the Stephen Leacock Museum, a national historic site (designated in 1994)—at nearby Old Brewery Bay, where he wrote many of his books.[201] His son, Stephen Jr. (known in town as Stevie), lived at the home for many years following his father's death. Stevie was somewhat more notorious than his father, but that is another story.

For many years, the opera house hosted politicians upstairs and criminals downstairs, with the politicians often the greater source of trouble. "The acoustics of the auditorium have drawn the greats, such as Oscar Peterson, the Marx Brothers, Bob Hope, k.d. lang, Mickey Rooney, Dan Hill, Liona Boyd, Blue Rodeo, George Canyon, Paul Brandt, Ron James, Manteca, Lighthouse, The Stampeders, April Wine and our own homie, Gordon Lightfoot. Many would-be greats got their start in school bands and local theatre groups, which continue to grace the stage."[202] Orillia's opera house is as appropriately

representative of the cultural elements of the city as the sun symbol is representative of the natural element.

It burned in a fire once (1915) and was rebuilt without its rear tower. People felt strongly about restoring the symbol of their modern town. From the 1930s to 1980s, as other priorities took hold, it was allowed to deteriorate. Finally, the city decided to spruce it up for its 100th anniversary in 1995. The seven-hundred-seat main auditorium served as a movie theatre from the 1920s to 1950. Glenn Gould, whose family had a cottage in Atherley, once performed there alone, just for the acoustics (and the lighting technician).[203]

Shortly after the opera house was restored, the old library collapsed. It had been refashioned during a radical modernization of downtown in the 1960s, with sharp-angle corners and clean facings of brick. The old substructure, built in 1911 with money from the Carnegie Foundation, didn't hold under the weight of a severe winter's snow. A temporary library was set up on Gill Street at Highway 12. After the traditional haggling and extended discussions, the new library was completed in 2012. It now graces the Mississauga Street block behind the opera house. In keeping with Orillian tradition, it remains controversial and is likely to be so for at least a generation.

In 1997, the city hall moved to its new offices in the old Tudhope Factory, alongside senior housing and what would be part of Lakehead University. On October 18, 1997, the opera house renamed its auditorium in honour of Gordon Lightfoot. Lightfoot started performing in high school in Orillia and moved on to national and international fame. He can still be found, on occasion, stopping in to see a performance or play one himself.

The opera house's legacy of music and the performing arts continues throughout the city. The Jazz Festival, Blues Festival, Beatles Festival and numerous weekends of arts and music are integral parts of the Orillia landscape. Perhaps the most significant of these takes place each summer and draws artists and crowds from around North America and the world: the Mariposa Folk Festival.

A legacy of the great annual folk festivals of the early 1960s, the Mariposa is the grande dame—the oldest in Canada. It opened at Lions Oval field in 1961, hosting Ian and Sylvia and other Canadian singers. Gordon Lightfoot arrived in tandem with Terry Whelan in 1963, just as Gordon's star was rising. This seems to have set a pattern for the festival, which holds auditions each year for new talent. Many of these performers and acts go on to national or international fame.

In her vision for the festival, Ruth Jones felt that it would "teach Canadians about their own national folk songs, give rising musicians the publicity they needed to attract record contracts, allow Canadian singers a chance to earn a successful living at home and promote the world's folk music to the world."[204] Alderman Pete McGarvey (credited with rescuing Leacock's home from the wrecking ball) embraced the concept and penned the name.

With the exception of a few years in Toronto, the festival has been held at Tudhope Park in Orillia. Tudhope Park was transferred to the city by J.B. Tudhope for exclusive use of the public. The festival is a fitting application of old J.B.'s intentions.

The Mariposa Folk Festival consistently boasts big-name headliners: Peter Yarrow, Arlo Guthrie, Jan Arden and Randy Bachman, just to name a recent few. It has evolved into a three-day festival of art, culture, music, learning and just plain fun. Hundreds of volunteers converge each July from all over Canada and North America to staff the festival, making Orillia the focal point of the North American music scene for at least one weekend.

Even during the dry times, there was room to party. In *The Sword*, Don Crawford noted that upon his return to Orillia in 1955, he found the supposedly dry town to be somewhat damp. Orillia, it seems, was surrounded by spots where one could get a drink without travelling too far. Some places in Orillia, such as the Club Pavilion, encouraged one to "brown bag it," as the practice was then to bring your own bottle and then they would supply the mix.[205]

Ray Cockburn certainly provided that mix musically:

> *As well as being a savvy hall operator, Ray was extremely respected and well liked by everyone in the music industry. He also listened to his customers. When the Club Pavilion (known by most Orillians as "The Pav") brought in rock music as part of its program, Ray encouraged the kids to form a Teen Town. This organization worked in cooperation with Ray, providing many suggestions regarding music format and bands they would like to see. Weekends at The Pav would usually feature a teen dance on Friday and an orchestra for the adults on Saturday. Ray took over the Kee in Bala and worked both sites. Ray could promise the bands he booked a gig at The Pav in Orillia one night and a job in Bala the next.*[206]

The Pav was another in the long history of musical venues and festivals in Orillia.

The fine arts are not to be ignored either. The rebirth of art in the Orillia area—home to Franklin Carmichael, Arthur Shilling, Paul Shilling and Elizabeth Wynn Wood—has led to several major festivals and gallery showings each year. A litany of artists has graced the city up to the present day, although not all were born here or stayed here.

Artist EDWARD SCROPE SHRAPNEL (grandson of Henry Shrapnel, inventor of the artillery shell) came to Canada with his father, Henry Needham Shrapnel, and spent his youth in Orillia. Much of Shrapnel's early subject matter consisted of watercolour landscapes of the Muskoka region, often with animals and native people.

MARY and ELEANOR HALLEN, the daughters of Reverend George Hallen (one of the first ministers in the area), plied the activity of sketching and painting in the manner of most well-heeled nineteenth-century ladies. They produced watercolour and pencil sketches, including a famous sketch of Sam Steele's Purbrook.

REVEREND R.W.E. GREENE, canon of St. James Church, was an accomplished artist and early teacher of Franklin Carmichael.

ELIZABETH WYNN WOOD, born in Orillia in 1903, is noted for her bust of Stephen Leacock, which is in the Orillia Public Library. Among her other major public works is the Welland-Crowland War Memorial in Chippawa Park, Welland, Ontario, dedicated in 1939, as well as the 1962 reliefs at Ryerson University in Toronto.

YUDAN STANTON produced drawings and paintings (one of which is in this publication), never letting his multiple sclerosis get in the way. His works illustrate life in Oro-Medonte and Orillia.

Mariposa Arts Theatre is a community theatrical troupe that has encouraged local participation since 1975 and stages plays by Canadian and other playwrights at the opera house.

C.A. HENRY arrived in Orillia with his family in 1957 from Belfast. His influences included Yudan Stanton, Arthur Shilling and Ada Torrence. His work evokes similarities to Shilling, but with his own focus on nature and faith.

DOUG SNEYD has been an Orillian since 1969. He has published numerous cartoons and illustrations, including a series in *Playboy*.

FRANKLIN CARMICHAEL was one of the founders of the "Group of Seven" and its youngest member. Carmichael participated in all of the

group's exhibitions. He was born at Orillia and studied at the Ontario College of Art and L'Academie Royale des Beaux-Arts at Antwerp.[207]

ARTHUR SHILLING emerged in the 1960s and '70s as an artist to rival Carmichael and the Group of Seven. From a family of thirteen children, he studied art briefly in Toronto and then proceeded to develop his own distinctive expressionist style. He moved away from traditional native imagery, preferring to paint people as he saw them, in bold strokes and colours. He returned to Rama and Orillia after his world fame had been secured to build a home-based studio and promote art among his people.

Arthur's brother, Paul, developed a unique style of portraiture, and his works are widely displayed in Orillia galleries and venues. The tradition carries on in Arthur's son, Travis, who has developed his own style and is coming to juried recognition. Ron Shilling continues in the family tradition as well, applying his talent to graphic arts. The family traces their lineage back to Big Chief Shilling, father-in-law of Antoine Gaudaur.

The artistic movement in Orillia has adopted many forms. The Peter Street Arts District, a block-long section below Mississauga, has spawned galleries and artistic celebrations. The Orillia District Arts Council lists more than 160 current members. Theatrical productions are common for children as well, with programs such as Duck Soup Productions and Mariposa Dance Company opening the vision for youngsters in the tradition of Orillia arts.

All told, Orillia has left legacies good and bad. The preponderance appears to favour the good.

Chapter 12
THE SUNSHINE CITY

A hive of bees will not stay in the possession of a quarrelsome family.
—*Orillia folk saying*[208]

You might have noticed that North Street lies south of South Street. While some might blame this on the return of beer sales, it has a less colourful explanation. Until 1888, the Orillia Township Council also administered the municipal affairs of the township of Matchedash. The official name of the township was the "Municipal Corporation of the Township of Orillia." It was more commonly known as the "Township of Orillia" or "Orillia Township." It was not until 1994 that the Township of Orillia amalgamated with the Village of Coldwater to form the Corporation of the Township of Severn. Thus, South Street was in the south end of Matchedash Township, while North Street was in the north end of Orillia.

DECLINE AND REBIRTH

By the 1980s, Orillia had lost something—perhaps its innocence. Perhaps, along with untold numbers of other small communities, it became part of the larger society as opposed to being independent and unique. It would

seem that the town split distinctly into those whose families have lived in Orillia from the beginning of the village and those who arrived later on.

For most of the late twentieth and early twenty-first centuries, Orillia saw a decline of traditional industry and factory jobs and growth in unemployment and homelessness. It watched as large employers with good-paying jobs left for towns offering more lucrative enticements. Good jobs gave way to employers offering the bare minimum. The leadership seems to have forgotten how generating its own electricity gave Orillia a leg up on the competition.

The shift in economics to a global production and delivery system served as the death knell for small, family-owned enterprise throughout the world. It did so in Orillia as well. The comfortable consistency of life experienced by Orillians since the end of the war eroded, replaced by uncertainty and constant challenges to the status quo.

Industry was no longer interested. To be sure, there were the businesses that continued to cater to the tourists—the cottagers. But these required fewer people to sustain them, and the larger portion of workers and individuals were left to move west or stay on *pogie*.

During the 1970s, the city decided that many of the older buildings should be replaced with apartments and other commercial buildings—hence the absence of many century properties and the presence of many boxlike structures. Sites once occupied by Ramsey Carriage, Fahralloy and Canada Wood boast apartments or retirement homes. A new pair of apartment buildings sits on reclaimed land along Old Barrie Road, and the Elgin Club takes up what was once commercial waterfront.

Portions of the old OTACO-Tudhope property were turned into city hall and senior housing. The weekly farmers' market, a tradition in Orillia since at least 1840, was located on the city hall lot. Upon completion of the new library, it was to have moved to that parking lot, and the use of the municipal lot was to be rescinded. Many vendors felt that there was insufficient parking room and decided instead to set up at the ODAS fairgrounds outside of town. It is simply another in a long string of controversies that keeps the city humming.

Despite ongoing issues, Orillia is far from foundering. Unlike major losers in the globalization of industry, the city survives. Perhaps it is because it is difficult for China to produce lakes, scenery, perch and pickerel for sale to North America.

Overall, there has been a 44.4 percent increase in the number of businesses operating in Orillia from 2001 to 2007. In addition, the

number of self-employed or cottage industry operations has increased by 55.3 percent, with much of that concentrated in the professional, scientific and technical services and construction sectors.[209]

Fahralloy-Fahramet-Kubota has done metal castings for reactor plants, as well as numerous other items, and continues operating a major facility along Highway 11. The cheap power from Orillia's own plant at Ragged Rapids initially brought the foundries. They required (and still do) so much power that they needed a cheap source. Kubota acquired the businesses, relocated to Highway 11 and still has its own direct Orillia power line for the same reason.[210]

Large sustainable businesses fell victim to the global economic downturns of the latter part of the twentieth century and did not reap the rewards from the upswing during the early twenty-first century. Perhaps the region evolved too efficiently to one of tourism and resorts to weather the reduced disposable income of folks from Toronto, Montreal or New York. Business demanded more investment from a leaner government; government demanded more from the province, which had little to give.

The Huronia Centre, largest employer in Orillia at the time, closed its doors in 2009. As it gradually downsized, more than one thousand workers needed to find jobs. More than two thousand residents had to find other accommodations. Social programs were put into place but have been chronically underfunded and often not effectively monitored. Increased availability of social services also brought in people from surrounding rural communities who needed assistance. The traditionally poorer sections of Orillia have attracted more and more people who are out of work and out of money. Orillians encounter more visible economic disparity as a result, although such class distinction is not new.

The pitch for Orillia as a "retirement" mecca was very successful. Several facilities opened in the area, such as Birchmere Retirement Residence (1981), Champlain Manor Retirement Residence (1997) and the Leacock Retirement Centre expansion (2013). The success of the retirement community industry led to the in-migration of an older population and a demand for greater community and health services. Not unlike many communities, Orillia has been aging, yet an older population now competes with new arrivals: students.

Lakehead University opened a campus in Orillia in 2008, and Georgian College has had a campus here for many years. Recently, both Lakehead and Georgian completed student dormitories. This added to the year-round population and has made a definite demographic impact

Regional commercial and private flights continue to arrive at downtown Orillia from farther north—although not directly to the LCBO. *Photo by author.*

on the town. It remains to be seen if the students will have a political impact on Orillia as well.

Rail service in the region continues with GO Transit, which operates commuter rail services from the Greater Toronto Area (GTA) to South Simcoe (Barrie and Bradford). Orillians commuting to Toronto or Vaughn Region can take the trains from those locations. The old railroad swing bridge at the Narrows is a monument to an earlier time. There is no train service to Orillia—the internal rights-of-way have been made into hiking and snowmobile trails or simply left abandoned.

However, there are still three main rail freight operators in Simcoe County, namely Canadian National Railway (CN), Canadian Pacific Railway (CPR) and Barrie Collingwood Railway. But this region does not rely heavily on public transit. In fact, the county says that slightly more than 1 percent of all daily trips use some form of alternative to motor vehicles as of 2012.

Simcoe County's transportation master plan aims to address some of the issues, including working closely with GO Transit and Ontario

Northland to extend passenger service throughout the county, but with freight transportation also firmly in mind, including "intermodal" facilities at various locations.[211] The county might have plans afoot that will affect Orillia. Perhaps someday Orillia will again be connected to the outside world through a rail system.

What has kept Orillia in the loop? The expansion of Highway 400 and King's Highway 11 and the existence of the Narrows certainly have. With the highways in place, tourists can get to Orillia easily for the weekend, and commuters can get to and from work. The lakes, particularly the Trent-Severn Waterway, ensure a flow of boaters coming to town. The Mariposa and other festivals draw crowds from afar. The arts community is growing and has potential to reshape the city.

Ice, Snow and Subdivisions

Ice and snow remain central themes for Orillia. Lake Couchiching is relatively shallow and freezes hard. The waterway becomes a roadway; pickups and cars take fishing enthusiasts a kilometre or more to ice huts. Snowmobiles travel the same routes in winter as power boats do in summer. People jog on the rail trails in summer and cross-country ski on them in the winter.

In the days before refrigeration, people used iceboxes. These required daily doses of ice. Lakes Couchiching and Simcoe allowed for the large-scale production of ice and regularly supplied icehouses as far away as Toronto. A.F. Hunter noted two occasions (in the winter of 1879–80 and again in that of 1889–90) when great quantities of ice were sent from the lake to other parts of Canada and to the United States; the mildness of these winters caused the dealers to come north for their supplies.[212]

Ice is still carved from the lake, but for recreational purposes. Orillia's Winter Festival offers an ice block maze for young and old. The blocks are sawn out of the lake ice, some by using antique tools. The hole remaining provides a convenient spot for the annual benefit polar bear swim.

One person who changed the face of Orillia for all time is Lou Orsi. The developer from Richmond Hill followed the 400 north to Orillia and, finding land for sale, invested in the future of the city. The 1990s

The Ice Maze—lost in a crystal conundrum. *Photo by author.*

saw immense tracts of housing completed. Despite issues arising from his developments and subdivisions, and there are many, Lou Orsi and others brought Orillia into the twenty-first century.

The hustle and bustle of suburbia arrived with the developments. The former marsh between the two ridges that define Orillia was turned into a sprawling shopping complex. The second ridge, West Ridge, was populated with subdivision housing. The area had only recently been annexed into Orillia City from Orillia Township. The township had merged with Matchedash and others to form Severn Township. Change was in the air.

Orsi's efforts set the stage for development for the next few decades, like it or not. Discord between the old families and the new arrivals continues, as it does in many towns. Orillia remains a city constantly searching its history to define its future. Each success will depend on attaining a consensus among its many segments...or perhaps they should be called "clans." The process continues to generate heated discussion.

Orillia's Recreational Complex

Large swaths of West Street South (and parts of James and Queen Streets) were the locations of Orillia's large industries and have been levelled over the years. Plans for the recovery and reuse of most of these sites have been on the drawing board for what seems like forever. One of the few unified efforts by the town's citizens was construction of the Recreational Complex at the Oval on Penetang Street, now slated for demolition. The new recreational complex would not be so cohesive.

The former OTACO site at 175 West Street South was the location on which Molson intended to build its Beaver Lumber centre. The struggle to build a new recreation complex for the city has become the single longest-running controversy in Orillia's history. Discussion started in 2001 at the city council.[213]

In 2003, the council unanimously accepted the transfer of the West Street South site from Molson for $1 in exchange for a tax receipt worth about $450,000. The city manager convinced the council to rely on Molson's own environmental studies, carried out by consultants Shaheen & Peaker, but never disclosed the results. Molson said nothing about its own study (prior to or after the transfer).[214]

Orillia commissioned its own probe by the same consultants in 2004. That study showed the site to be heavily contaminated with vinyl chloride, slag and runoff of processing chemicals. The city arranged an initial $1.7 million in an effort to reclaim the land.[215] After the discovery, Orillia started to truck forty thousand tons of contaminated soil to the lakeside landfill on Kitchener Street. As construction crews start digging, the watchdog group Citizens' Coalition filed an injunction at the county courthouse to stop the work, and years of corrosive debate began.

Molson says that the decision to keep its environmental study under wraps for two years was a legal precaution. "There was no real reason it was kept confidential other than legal precautionary measures," says David Jones, Molson's director of public affairs.[216]

"Legal precautionary measures"? Molson somehow managed to sell the property to the city for $1 and made it look like a real deal at that. The city was stuck with contaminated property and required to clean it up at an immense cost to taxpayers, and as of this writing, it remains an undeveloped brownfield.

The ensuing debate over what to do with the land would have made Ben Johnson smile. After cleaning it up, the city proposed, then stopped, then proposed, then stopped and now again proposes a recreational site. In a move destined to confound the issue even further, the city council made a conditional offer in 2011 to buy four parcels of the 144-year-old E. Long property at 174 West Street South, across from the Molson site, for the same purpose. In the meantime, the old David Church School, at least a kilometre away, was demolished to make way for a recreational centre. Perhaps the place that positions itself as the gateway to the Muskoka Region has reason to develop several such resources.

There have been long, heated discussions in local pubs about how this happened. A large deposit near the town dump remains, and the recreational centre is still on the drawing board. It was certainly not a deal in the best interest of the citizens or of a cohesive community. Some critics point to the city leadership, and some point to the historical indecisiveness of Orillia in general. In some ways, the Molson deal was a reverse of the deal that the town founders gave the Ojibwe.

The irony is that this controversy continues the process of almost every municipal action taken over the 180-year history of British rule. Motions for progress clash with motions for heritage, with the result being inertia. Orillians will work it out, and the end result will be a welcome part of the community, but to do so will probably take a generation.

Sports

Brian Orser won the Olympic silver medal in 1984 and 1988 in figure skating. He was from Penetanguishene but, in the tradition of things Orillian, is lauded as a hometown hero because he studied at the Mariposa School of Skating, which was in Orillia at the time. In 1988, the council passed on supporting an arena for skating at Georgian College. The skating school pulled up stakes and moved to Barrie. In somewhat of a concession, Brian had an ice rink named for him on Gill Street. In 2010, Orillia built the twin pads at Rotary Place near Lakehead University. It is probable that, at some point, an Orillia Olympian will emerge again.

Orillia minor hockey has been a mainstay of the area. Children of all ages are introduced to hockey. Evelyn Davis and her CWAC colleagues

would be pleased to see that girls are encouraged to play hockey, too. The rinks at Rotary Place, Rama Mnjikaning Arena Sports Complex and Orser Arena serve the programs. The Ontario Provincial Junior A Hockey League has also seen Orillians compete, principally under the logo of the Terriers. Several players have gone on to the American Hockey League and National Hockey League over the years.

Not all recreation in Orillia involves ice. Water sports abound as well. Orillia was once known as an active centre for rowing and it remains a place known for boating and sailing. Jake Gaudaur, one of the world's greatest oarsmen, was born and raised in Orillia and was a descendent of Antoine Gaudaur. He trained on Lake Couchiching and, from 1892 to 1898, won the World Championship in the Double Sculls on Lake Couchiching; established a world record for "Three Miles with a Turn" at Austin, Texas; and won the Single Sculls World Championship on the Thames in England.[217]

Orillia also boasts a swim team of renown. The Channel Cats offer training and support for swimmers of all ages. They compete regularly throughout the province and Canada and carry on a tradition of water sports. Swimming has always been a major part of the many summer camps that dotted Couchiching and Simcoe.

Orillia has a very active Parks and Recreation Department boasting affordable programs for all ages and intelligent, well-trained staff. The tracks along Lake Simcoe's northern shore that went up to Orillia were torn up back in the 1990s to create a new rail trail. The city set up a walking/running trail and named it after Gordon Lightfoot. Snowmobile trails run through town (it is interesting to have to wait at a street corner while a few cross). The area around the city boasts several golf courses, hiking trails and environmental reserves. Anyone who says that life in Orillia is boring hasn't been looking.

What of the Bees?

The old Orillia adage was correct. The bees were tired of discord in Orillia and moved their hive to a place where there was growing accord. The Ojibwe of Mnjikaning First Nation in Rama conceived of a plan to finally end the decades of poverty, isolation and discrimination. As

Casino Rama, 2013. *Photo by author.*

masters of their land, at least according to law, they arrived at a unique solution for the time.

In the spring of 1972, the Ojibwe of Rama held a traditional council meeting. People were told of the meeting, and all were invited, even required, to attend. The chiefs, husbands, fathers, wives, mothers and elders of the several clans came, as they had for centuries, to discuss the issues before the tribe. These issues had not changed for nearly 150 years: poverty, 85 percent unemployment, illness, bad water, scurrilous agents and inadequate housing and infrastructure.[218]

The great plan was proposed by George St. Germain, a pilot and entrepreneur. The tribe was incredulous. It had never been done—it could never be done. However, in 1996, George's dream became reality, and Casino Rama opened to the public. George did not live to see it but is honoured in the name of the top-end restaurant at the Casino: St. Germain's.[219]

The natives have lifted themselves from the circumstances dictated so long ago by people like Stinson and Jarvis. They have become self-sufficient, in their way. Unemployment at Rama is no longer 85 percent. As Sherry Lawson noted: "Casino Rama revenues have helped Mnjikaning build a school, seniors complex, fire hall, police station and a daycare centre. Everyone who is able to work is working. There are lots of new vehicles in the driveways. The water is finally fit to drink."[220]

Orillia has seen benefits as well. Many Orillians, jobless with the loss of commerce and industry, now have work. Suppliers have a buyer, and tourism operators have a focus. As has been the case for centuries, life on one side of the Narrows exists hand in hand with the other side.

The bees moved their hive to Rama and set up next to the rising sun symbol of the Mnjikaning First Nation—the same sun symbolized in Orillia's city flag, the same sun that draws millions of visitors and travellers to this corner of Ontario and the same sun that Chief Yellowhead said was placed here so we would remember the deeds of our ancestors.

And So Here We Are

The sketches of Mariposa periodically arouse a degree of wistfulness in Orillians. Old-timers wish for the days when things were simpler. Newcomers search, in vain, for the images and people Leacock described. The city presses forward, into the twenty-first century, desperately clinging to the image of an earlier time and place that, in some sense, never was.

The central concern of *Sunshine Sketches* could be neither better nor more artfully put: the worthwhile from the past—from Mariposa— must be remembered forward if there is to be any hope for a full and continuous life in the present and the future.[221]

Orillia is no longer that country village peopled by post-Victorian high achievers of which Leacock wrote. It has evolved into a modern city, no longer able keep modern problems at arm's length by distance or time. Orillia has issues, but it also has the same core of hardworking, determined citizens it did when the soil needed tilling and the lumber needed milling.

The credulous aspirations of the characters in *Sunshine Sketches*, pushed forward despite recurrent bumps and bruises, accurately depict the Orillia of today. Leacock's home on Brewery Bay, built in 1928, is a memorial to the author thanks to an active and diligent effort to save the place from razing and development. At French's Ice Cream Stand at Couchiching Beach Park, one may sit in the same wire stool as did Leacock and enjoy a creamy refreshment while observing the people of modern Mariposa.

Perhaps another series of stories will be born of one of Orillia's many artists, performers and writers. Each spring, hordes of fishing enthusiasts

(and rank amateurs) compete in the Orillia Perch Derby. Blues, jazz, theatre and art have sunk new roots in Mariposa. Immigrants still arrive to build new lives, although today, most are from Toronto and other crowded cities.

As with the Ojibwe of Rama and their phoenix-like reemergence in the twenty-first century as a determined and unified people, the citizens of Orillia remain faithful to their past but committed to the future. If another one hundred years see changes not yet imagined, there will still be the lakes, the Narrows and the fish.

NOTES

CHAPTER 1

1. National Archives of Canada, Minutes of the General Council Meeting, Chief Yellowhead's Reading of the Wampum Belt, 85–86.
2. Farwell, *Ontario County*.
3. Larson, "Geological History of Glacial Lake Algonquin."
4. Ibid.
5. Hunter, *Orillia's Historic Waterfront*.
6. Hunter, "Notes on Sites of Indian Villages."
7. Ibid.
8. Hunter, *Lake Simcoe and Its Environs*.
9. Town of Innisfil, *Stage 1 Archaeological Assessment*, PIF #P007-499-2012.
10. Wright, "Dougall Site," 3–23; Ringer, "Atherley Narrows Fish Weir Complex."
11. Ringer, "Atherley Narrows Fish Weir Complex."
12. Mnjikaning Fish Fence Circle website.
13. Douglas, interview and discussion with author.
14. Wikipedia, "Toronto Carrying Place Trail."
15. Ibid., "Koochiching County Minnesota."
16. Ibid., "Toronto Carrying Place Trail."
17. Ibid.
18. Ringer, "Atherley Narrows Fish Weir Complex."

Chapter 2

19. Warrick, *Population History of the Huron-Peton*, 204.
20. Ibid.
21. Ibid., 160.
22. Berry, *Samuel de Champlain*; Fischer, *Champlain's Dream*.
23. Knight and Snyder, *1981 Excavations at the Ball Site*.
24. Fitzgerald, "Is the Warminster Site," 3–7; Knight and Snyder, *1981 Excavations at the Ball Site*.
25. Fitzgerald, "Is the Warminster Site."
26. Hunter, "Notes on Sites of Indian Villages."
27. Ibid.
28. Lalemant, *Huron Relations*.
29. Branka, "Huron-Wendat Feast."
30. Allen, "What's in a Name?"
31. Ibid.
32. Allen, "Wa-nant-git-che-ang," 32.
33. Wright, "Dougall Site," 3–23.
34. Ibid.
35. Lutins, "Prehistoric Fish Weirs."
36. Richmond, *Orillia Spirit*, 14.
37. Schmalz, *Ojibwa of Southern Ontario*.
38. Copway, *Traditional History and Characteristic Sketches*.
39. Ibid.
40. Editor note in Robertson, *Diary of Mrs. John Graves Simcoe*.
41. Warren, "History of the Ojibwa People."
42. Douglas, interview and discussion with author.
43. Warren, "History of the Ojibwe People."

Chapter 3

44. Sabine, *Biographical Sketches of Loyalists*.
45. Taylor, "Late Loyalists," 4.
46. Shannon, "Land."
47. Richmond, *Orillia Spirit*.
48. Hamilton and Sebert, *Significant Dates in Canadian Surveying Mapping*.

49. Robertson, *Diary of Mrs. John Graves Simcoe.*
50. Hunter, *History of Simcoe County*, vol. 1.
51. Snider, "Cowan's Trading Post."
52. Hunter, *History of Simcoe County*, vol. 2.
53. Stamp, *Early Days in Richmond Hill.*
54. Textor, "Colony of Emigres in Canada," 57–58.
55. Ibid.
56. Hunter, *History of Simcoe County*, vol. 2.
57. Drury, *All for a Beaver Hat.*
58. Raymont, "Descendants of William Roe."
59. Hunter, *History of Simcoe County*, vol. 2.
60. Millman, "Anderson, Thomas Gummersall"; Rowe, "Anderson Record," 109–28.
61. Honore Joseph Bailley entered into a financial partnership with Dominic Rousseau of Montreal; their company dominated the fur trade on the upper Great Lakes out of Mackinac Island and challenged the giant North West Company. Rousseau and Bailley maintained large warehouses on Mackinac and in Montreal, trading in numerous locations with several fleets of voyageurs. It is likely that one of these voyageurs was Antoine Gaudaur.
62. Hunter, *History of Simcoe County*, vol. 2.
63. Ibid.

Chapter 4

64. Shannon, "Land," 19.
65. Crawford, *Hills of Oro and Other Landmarks.*
66. Wikipedia, "Family Compact."
67. Shannon, "Land," 21–25.
68. Webster, "Caldwells and the Lucks," Reminiscing in Simcoe County.
69. Shannon, "Land."
70. The "clearances" (as they are called) were the wholesale destruction of small tenant farms by landowners so as to open large fields for sheep. The wool industry demanded more raw material. Small farmers were tossed out onto the shoulders of the parish.
71. Shannon, "Land," quoting the research of Helen Cowan and Lillian Gates.
72. Ibid.

73. Ibid., 20.
74. Bray, "After Waterloo."
75. Ibid.
76. Reed, "Story of Thomas Williams."
77. Wilson, "More Pioneer Reminiscences."
78. Russel, "Forest into Farmland," 326–39.
79. Day, "Transportation of the Early Days."
80. Jamieson, *Sketches in Canada*.
81. Langton, *Gentlewoman in Upper Canada*, 95.
82. Ibid., 31–32.
83. Gill, "Memories of the Late Mrs. Leonard Wilson."
84. Reed, "Story of Thomas Williams."
85. Hunter, *History of Simcoe County*, vol. 2.
86. Jamieson, *Sketches in Canada*, 300.
87. Jones, *Life and Journals of Kah-ke-wa-quo-na-by*.
88. Ibid., 159.
89. Parr, "Hired Men," 91–103.
90. *Simcoe County Land Book*, reel C1614, A22/40.
91. Hunter, *History of Simcoe County*, vol. 2.
92. Richmond, *Orillia Spirit*.
93. Sanderson, *First Century of Methodism*, 230.
94. Ibid., 278.

Chapter 5

95. Aboriginal Affairs and Northern Development Canada, "First Nations and the War of 1812."
96. Dictionary of Canadian Biography, "Musquakie."
97. Douglas, interview and discussion with author.
98. Leighton, "Compact Tory as Bureaucrat."
99. Jamieson, *Sketches in Canada*.
100. MacLean, "Positive Experiment in Aboriginal Education," 23–63.
101. Leighton, "Compact Tory," 1981.
102. Rowe, "Anderson Record."
103. Ibid.
104. Millman, "Anderson, Thomas Gummersall."

105. Dictionary of Canadian Biography, "Musquakie."
106. Garbutt, "Bass Lake Pioneers."
107. Gill, "Memories of the Late Mrs. Leonard Wilson."
108. Millman, "Anderson, Thomas Gummersall."
109. Jamieson, *Sketches in Canada*.
110. MacLean, "Positive Experiment in Aboriginal Education."
111. Garbutt, "Bass Lake Pioneers."

CHAPTER 6

112. History of St. James Church website.
113. The records are dated 1840, even though the conventional wisdom has the natives moving in 1836–38. Transactions took a long time to be recorded, which might account for this discrepancy.
114. Jarvis, letter from Stephen Jarvis.
115. Ibid.
116. Ibid.
117. Ibid.
118. Council, reel 2112, vol. 1 22/6, June 1840, Simcoe County Archives.
119. Orillia Public Library, Archives Transcription, "Place of the Fence."
120. Ibid.
121. Council, reel 2112, vol. 1 22/6, June 1840, Simcoe County Archives.
122. Hall, "John Aisance."
123. Transcribed copy in OMAH archives.
124. Hunter, *History of Simcoe County*, vol. 2.
125. Gaffield and Levin, "Dependency and Adolescence," 35–47.
126. Jamieson, *Sketches in Canada*, 167.
127. MacLean, "Positive Experiment in Aboriginal Education," 23–63.
128. Ibid.
129. Copway, *Traditional History and Characteristic Sketches*.
130. MacLean, "Positive Experiment in Aboriginal Education."
131. Carman and Sutherland, *Memorandum*.
132. MacLean, "Positive Experiment in Aboriginal Education."
133. Jamieson, *Sketches in Canada*.
134. Schmalz, *Ojibwe of Southern Ontario*.

Chapter 7

135. Parr, "Hired Men," 91–103.
136. Harvie, interview and discussion with author.
137. Parr, "Hired Men."
138. Fowke, *Songs of the Northern Shanty Boys*.
139. Parr, "Hired Men."
140. Richmond, *Orillia Spirit*.
141. Cotton, *Whiskey and Wickedness*, 64.
142. Ibid.
143. Ibid., 62.
144. Fowke, *Songs of the Northern Shanty Boys*.
145. Richmond, *Orillia Spirit*, 35.
146. Cotton, *Whiskey and Wickedness*.
147. History of St. James Church website.
148. Hunter, *History of Simcoe County*, vol. 2.
149. Gaffield and Levin, "Dependency and Adolescence," 35–47.
150. Trout and Trout, *Railways of Canada*, 37.
151. Ibid., 106.
152. Cook, "South Orillia."
153. Lapointe, "Canadians in the American Civil War."
154. Richmond, *Orillia Spirit*.

Chapter 8

155. Craig, *Simcoe County*, 20.
156. Copy of letter in OMAH Collection.
157. Orillia Power website.
158. Ibid.
159. MacLeod, "Orillia."
160. Orillia Power website.
161. Ibid.

Chapter 9

162. Government of Canada, National Defence and Canadian Forces, "Grey and Simcoe Foresters."
163. Fleming, *Wartime Letters of Leslie and Cecil Frost*.
164. Chinese-Canadians: Profile from a Community, "Wee Hong Louie."
165. Ibid.
166. The full Walter Louie story is still being researched at this writing.
167. Dawson, "Caldwell Skipped Last City Team."
168. Letter in possession of Don Kendall, Orillia.
169. Richmond, *Orillia Spirit*, 41.
170. Craig, *Simcoe County*.
171. Richmond, *Orillia Spirit*.
172. Ibid., 59.
173. Cotton, *Whiskey and Wickedness*.
174. Richmond, *Orillia Spirit*.
175. Mark Douglas, quoted in Lawson, *I've Been Shot At*.
176. Ibid.
177. Orillia Heritage Centre, "Boyd's Horse."
178. Ross, "Century-Old Atherley Arms."

Chapter 10

179. Forsyth, "Orillia's Forgotten Army Camp."
180. Ibid.
181. Ibid.
182. Davis, interview transcript, OMAH Archives.
183. Ibid.
184. Ibid.
185. Richmond, *Orillia Spirit*, 77.
186. Recipe found at www.gettystewart.com.
187. Craig, *Simcoe County*, 92.
188. Ibid., 93.
189. Biggar, *Works of Samuel de Champlain*, vol. 3.
190. Robertson, *Diary of Mrs. John Graves Simcoe*.

191. Craig, *Simcoe County*, 62.
192. King's Highways of Ontario, "Ontario Highway 11-B, Orillia."

Chapter 11

193. Hunter, *History of Simcoe County*, vol. 1.
194. Hurd, *Institutional Care of the Insane*, 153.
195. Ibid.
196. Ibid.
197. Reaume, "Patients at Work."
198. Burton, "What's Wrong at Orillia."
199. Quade, interview with author.
200. Russel, Leacock Museum website.
201. Ibid.
202. Orillia Opera House, "History."
203. Richmond, *Orillia Spirit*.
204. Ibid., 103.
205. Johnson, *The Sword* 8, no. 8 (August 2011).
206. Ibid.
207. Archaeological and Historic Sites Board, Department of Public Records and Archives of Ontario.

Chapter 12

208. Waugh, "Canadian Folk-Lore from Ontario." 4–82.
209. City of Orillia website.
210. Patterson, interview and discussion with author.
211. Bowe, "County Rail Plans on Track."
212. Hunter, *Lake Simcoe and Its Environs*.
213. Szijarto, "MURF."
214. Ibid.
215. Ibid.
216. Ibid.
217. Orillia Rowing Club website.

218. Lawson, *I've Been Shot At*.
219. Ibid.
220. Ibid.
221. Lynch, "Religion and Romance in Mariposa."

BIBLIOGRAPHY

Allen, William A. "Wa-nant-git-che-ang: Canoe Route to Lake Huron through Southern Algonquia." *Ontario Archaeology* 73 (2002).

Baehre, Rainer, "Pauper Emigration to Upper Canada in the 1830s." *Historie Sociale/Social History* 14, no. 28 (1981): 340.

Berry, Gerald. *Samuel de Champlain*. Richmond Hill, ON: Simon & Schuster of Canada, Limited, 1967.

Biggar, H.P., ed. *The Works of Samuel de Champlain*. Vol. 3. Toronto: Champlain Society, 1929.

Bixby, M.G. *Industries of Canada*. Toronto: self-published, 1887.

Bladen, M.L. "Construction of Railways in Canada to the Year 1885." *Contributions to Canadian Economics* 5 (1932): 43–60. Published by Wiley on behalf of Canadian Economics Association. http://www.jstor.org/stable/136530.

Butts, Ed. *True Canadian Explorers*. Toronto: Key Porter Books, Limited, 2008.

Byers, Mary. *Lake Simcoe and Lake Couchching*. Erin, ON: Boston Mills Press, 1999.

Clark, Peter Dooyentate. *Origin and Traditional History of the Wyandotts, and Sketches of Other Indian Tribes of North America*. Toronto: Hunter-Rose, 1870.

Copway, G. (Kah-ge-ga-gah-bowh). *The Traditional History and Characteristic Sketches of the Ojibwe-Nation*. London, 1850.

Cotton, Larry D. *Whiskey and Wickedness*. Vol. 2, *Orillia, Ontario 1800–1900*. Barrie, ON: Larry Cotton Assoc., 2004.

Craig, John. *Simcoe County: The Recent Past.* Barrie, ON: Corporation of the County of Simcoe, 1977.

Crawford, Tim, ed. *Hills of Oro and Other Landmarks.* Oro-Medonte, ON: Township of Oro Historical Committee, 1993.

Crossby, P.A., ed. *Lovell's Gazetteer of British North America.* Montreal: John Lovell and Son, 1881.

Day, K. "Transportation of the Early Days." *Orillia Portraits.* Vol. 1. Edited by N. Ireton, R. Thomson and G. Crooks. Orillia, ON: Orillia Historical Society, Stubley Printing, 1966.

Dionne, Narcissa -Eutrope. *Les Ecclesiastiques et Les Royalistes Francais Refugies au Canada.* Quebec, 1905.

Dolin, Eric Jay. *Fur, Fortune and Empire.* New York: W.W. Norton and Company, 2010.

Drury, Ernest C. *All for a Beaver Hat.* Toronto: Ryerson Press, 1959.

Duncan, Dorothy. *Hoping for the Best, Preparing for the Worst: Everyday Life in Upper Canada, 1812–1814.* Toronto: Dundurn Press, 2012.

Farwell, J.E. *Ontario County.* Whitby, ON: Gazette-Chronicle Press, 1907.

Fischer, David Hackett. *Champlain's Dream.* New York: Simon & Schuster, 2008.

Fischer, W. Allen. *The Genesis of Barrie, 1783–1858.* Barrie, ON: Printing Unlimited, 1987.

———. "The Road through Simcoe's County." *East Georgian Bay Historical Journal.* Vol. 4. Edited by Gail Lucas. Elmvale, ON: East Georgian Bay Historical Foundation, 1985.

Fitzgerald, William R. "Is the Warminster Site Champlain's Cahiagué?" *Ontario Archaeology* 45 (1986): 3–7.

Fleming, R.B. *The Wartime Letters of Leslie and Cecil Frost, 1915–1919.* Life Writing Series. Waterloo, ON: Wilfrid Laurier University Press, 2007.

Fowke, Edith. *Songs of the Northern Shanty Boys.* Austin: University of Texas Press, 1970.

Fraser, Alexander. *Fifth Report of the Bureau of Archives for the Province of Ontario.* Toronto: L.K. Cameron, 1908.

Frim, Monica. *Secrets of the Lakes.* Toronto: Lynx Images, 2002.

Gaffield, Chad, and David Levin. "Dependency and Adolescence on the Canadian Frontier: Orillia, Ontario in the Mid-Nineteenth Century." *History of Education Quarterly* 18, no. 1 (Spring 1978): 35–47.

Garbutt, Mary E. "Bass Lake Pioneers: Reminiscences." *East Georgian Bay Historical Journal.* Vol. 5. Edited by Irene Golas. Elmvale, ON: East Georgian Bay Historical Foundation, 1989.

———. *Medonte: A Township Remembered*. Oro-Medonte, ON: Oro-Medonte History Committee, 2003.

Goldie, John. *Diary of a Journey through Upper Canada and Some of the New England States*. Toronto: W. Tyrell, 1897. Originally published in 1819.

Hale, C.H. "Chief William Yellowhead: Sketch of the Life of William Yellowhead, Head Chief of the Chippewas, Whose Indian Name Was Musquakie, 1769–1864." *Orillia Portraits*. 2nd ed. Orillia, ON, 1966.

———. *Reminiscences*. Orillia, ON: Stubley Printing, 1963.

Hamilton, A.C., and L.M. Sebert. *Significant Dates in Canadian Surveying Mapping and Charting*. Ottawa, ON: Canadian Institute of Geomatics, Geomatica Press, 1996.

Heidenreich, C.E. "A New Location for Carhagouha: Recollect Mission in Huronia." *Ontario Archaeology* (August 1967). Ontario Archaeological Society, Toronto.

Hewitt, Grace Henderson. *Early Days in Simcoe County*. Orillia, ON: Orillia Women's Canadian Club, Orillia Public Library, n.d.

Hind, Andrew, and Maria DaSilva. *Secrets of Lake Simcoe*. Toronto: James Lorimer and Company, 2010.

Hunter, Andrew F. *A History of Simcoe County in Two Volumes*. Vol. 1, *Its Public Affairs*. Toronto: Simcoe County Council, Warwick Bros. & Rutter, Limited, 1909.

———. *A History of Simcoe County in Two Volumes*. Vol. 2, *The Pioneers*. Toronto: Simcoe County Council, Warwick Bros. & Rutter, Limited, 1909.

———. *Lake Simcoe and Its Environs*. Toronto: Coles Printing Company, Limited, 1979. Originally published in 1893.

———. "Notes on Sites of Indian Villages, Townships of North and South Orillia." *Ontario Archaeological Report for 1903*. Toronto: Ontario Archaeological Society, 1903.

Hunter, Donald A. *Orillia's Historic Waterfront: 1855 to 1985*. Orillia, ON: Orillia Museum of Art and History, Kerry Hill Publications, 2003.

Hurd, Henry M. *The Institutional Care of the Insane in the United States and Canada*. Vol. 1. Baltimore, MD: Johns Hopkins University Press, 1916.

Ironside, Allen. "The Tudhope Family." *East Georgian Bay Historical Journal*. Vol. 2. Edited by Gail Lucas. Elmvale, ON: East Georgian Bay Historical Foundation, 1982.

Jamieson, Anna. *Sketches in Canada and Rambles Among the Red Men*. 3 vols. London: Longman, Brown, Green and Longman, 1852. New edition of the 1837 printing. Available at the Internet Archive, http://archive.org/details/cihm_37215.

Jones, Arthur E. "'Wendake Ehen,' or Old Huronia." Monograph in *Fifth Report of the Bureau of Archives for the Province of Ontario*, by Alexander Fraser. Toronto: L.K. Cameron, 1908.

Jones, Peter. *Life and Journals of Kah-ke-wa-quo-na-by (Rev. Peter Jones)*. Toronto: Anson Green, 1860.

Key, Wallace. *The Story of Oro*. Oro-Medonte, ON: Oro Township Historical Committee, 1972.

Knight, D., and M. Snyder. *The 1981 Excavations at the Ball Site*. Report on file at the Department of Sociology and Anthropology, Wilfrid Laurier University, Waterloo, Ontario.

Lalemant, Jerome, S.J. *Huron Relations from 1639 to 1645*. Edited by Lucien Campeau, S.J. Reprinted with post-translation by William Lone, S.J. Midland, ON: Martyrs' Shrine, 2006. Originally published in 1645.

Langton, H.H. *A Gentlewoman in Upper Canada: The Journals of Anne Langton*. Toronto: Clarke-Irwin and Company, Limited, 1950.

Larson, Curtis E. "Geological History of Glacial Lake Algonquin and the Upper Great Lakes." *U.S. Geological Survey Bulletin*. Denver, CO: U.S. Government Printing office, 1987.

Lawson, Sherry. *I've Been Shot At, What's Your Excuse?* Longford Mills, ON: self-published, 2007.

Leighton, Douglas. "The Compact Tory as Bureaucrat: Samuel Peter Jarvis and the Indian Department, 1837–1845." *Ontario History* 73, no. 1 (March 1981). Ontario Historical Society, Toronto.

Long, Clare. *Longview: The Story of an Orillia Enterprise*. Orillia, ON: Orillia Public Library, 1995.

Lutins, Allen. "Prehistoric Fish Weirs in Eastern North America." Master's thesis, Department of Anthropology, SUNY-Binghamton, New York, 2004.

Lynch, Gerald. "Religion and Romance in Mariposa." In *Stephen Leacock: A Reappraisal*, by D. Staines. Ottawa: University of Ottawa Press, 1986.

MacLean, Hope. "A Positive Experiment in Aboriginal Education: The Methodist Ojibwe Day Schools in Upper Canada, 1824–1833." *Canadian Journal of Native Studies* 22, no. 1 (2002): 23–63.

MacLeod, Douglas. "Orillia: A Geographic Study of a Southern Ontario Town." BA thesis, University of Toronto, 1953.

McDonald, Ross. *Why Call It That? The Origin of Most of the Street and Place Names in Orillia*. Orillia, ON: Orillia Historical Society, 1990.

Millman, T.R. "Anderson, Thomas Gummersall." *Dictionary of Canadian Biography*. Vol. 10. Toronto: University of Toronto/Université

Laval, 2003. http://www.biographi.ca/en/bio/anderson_thomas_gummersall_10E.html.

Moore, Christopher. *The Loyalists: Revolution, Exile, Settlement.* Toronto: McClelland and Stewart, 1994.

Murdoch, Su. *Beautiful Old Orillia.* Orillia, ON: Orillia Museum of Arts and History, 2000.

———. "The Titus Hibbert Ware Diary of a Journey from Liverpool, England to Orillia, Simcoe County 1844." *East Georgian Bay Historical Journal.* Vol. 1. Transcribed and edited by Irene Golas. Elmvale, ON: East Georgian Bay Historical Foundation, 1981.

———. "The Wish to Make a Sketch of It: George Hallen and Family." *East Georgian Bay Historical Journal.* Vol. 2. Edited by Gail Lucas. Elmvale, ON: East Georgian Bay Historical Foundation, 1982.

O'Brien, W.E., Lieutenant Colonel. "Early Days in Oro." *Pioneer Papers* 2 (1905). Simcoe County Pioneer and History Society, Barrie, Ontario.

Parr, Joy. "Hired Men: Ontario Agricultural Wage Labour in Historical Perspective." *Labour/Le Travail* 15 (Spring 1985): 91–103. Canadian Committee on Labour History and Athabasca University Press, Edmonton, AB.

Reaume, Geoffrey. "Patients at Work: Insane Asylum Inmates' Labour in Ontario 1841–1900." *Mental Health and Canadian Society.* Edited by J.E. Moran and D. Wright. Montreal: McGill-Queens University Press, 2006.

Reed, W.T. "The Story of Thomas Williams." *Orillia Portraits.* Vol. 1. Edited by N. Ireton, R. Thomson and G. Crooks. Orillia, ON: Orillia Historical Society, Stubley Printing, 1966.

Richmond, Randy. *The Orillia Spirit.* Toronto: Dundurn Press, 1996.

Ringer, R. James. "The Atherley Narrows Fish Weir Complex: A Submerged Archaic-to-Historic-Period Fishing Site in Ontario, Canada." *Revista de Arqueología Americana* 26 (2008). Institute of Pan-American Archaeology and History, OAS, Washington, D.C.

Robertson, J. Ross. *The Diary of Mrs. John Graves Simcoe* [Elizabeth Gwillim] *with Notes and Bibliography.* Toronto: William Briggs, 1911.

Rogers, Edwin S., and Donald B. Smith. *Aboriginal Ontario: Historical Perspectives on the First Nations.* Ontario Historical Studies Series. Toronto: Dundurn Press, 1994.

Rosenthal, M. "Early Post Offices of the Orillia District." *Orillia Portraits.* Vol. 1. Edited by N. Ireton, R. Thomson and G. Crooks. Orillia, ON: Orillia Historical Society, Stubley Printing, 1966.

Rousseau, Marcel. *Post Card Memories: Orillia.* Orillia, ON: Rose Printing, 2013.

Rowe, S. "Anderson Record from 1699 to 1896." *Papers and Records.* Vol. 6. Toronto: Ontario Historical Society, 1905.

Russel, Peter A. "Forest into Farmland: Upper Canadian Clearing Rates, 1822–1839." *Agricultural History* 57, no. 3 (July 1983): 326–39. Agricultural History Society, http://www.jstor.org/stable/3742458.

Sabine, Lorenzo. *Biographical Sketches of Loyalists of the American Revolution, with an Historical Essay.* Vol. 1. Boston: Little, Brown and Company, 1864.

Sanderson, J.A. *First Century of Methodism in Canada.* Vol. 1. Toronto: William Briggs, 1908.

Schmalz, Peter. *The Ojibwa of Southern Ontario.* Toronto: University of Toronto Press, 1991.

Shannon, Bill. "Land: Struggle for Settlement." MA thesis, Bishops University, Sherbrooke, Quebec. Collingwood Historical Society and William Shannon, Ottawa, 2000.

Shreve, Dorothy Shadd. *The AfriCanadian Church: A Stabilizer.* Ontario: Paideia Press, Jordan Station, 1983.

Snider, C.H.J. "Cowan's Trading Post." *Orillia Portraits.* Vol. 1. Edited by N. Ireton, R. Thomson and G. Crooks. Orillia, ON: Orillia Historical Society, Stubley Printing, 1966.

Stamp, Robert M. *Early Days in Richmond Hill: A History of the Community to 1930.* Electronic edition. Richmond Hill, ON: Richmond Hill Public Library Board, 1991.

Taylor, Alan. "The Late Loyalists: Northern Reflections of the Early American Republic." *Journal of the Early Republic* 27, no. 1 (Spring 2007). University of Pennsylvania Press, Philadelphia.

Textor, Lucy Elizabeth. "A Colony of Emigres in Canada (1798–1816)." PhD diss., Yale University, 1905. Available at University of Toronto Archives, Toronto.

Thomson, R. "Indian Sites in the Orillia District." *Orillia Portraits.* Vol. 1. Edited by N. Ireton, R. Thomson and G. Crooks. Orillia, ON: Orillia Historical Society, Stubley Printing, 1966.

Tiller, John, and Ian Winchester. "Modelling a City with a Village: Orillia and Hamilton, 1850–1870." Manuscript, Department of History and Philosophy, Ontario Institute for Studies in Education, Orillia Public Library Collection, Orillia, Ontario, 1977.

Town of Innisfil. *Stage 1 Archaeological Assessment, Churchill Reservoir and Pump Station.* Town of Innisfil, February 2013 Archaeological Research Associates Ltd. PIF #P007-499-2012.

Trigger, Bruce G. *The Children of Aataentsic: A History of the Huron People to 1660.* Vol. 1. Montreal: McGill-Queen's University Press, 1976.

———. *The Huron: Farmers of the North.* Toronto: Holt, Rinehart and Winston, 1969.

Trout, J.M., and Edward Trout. *The Railways of Canada.* Facsimile edition. Toronto: Coles Publishing Company, 1970. Originally published in 1873.

Vogel, Virgil. *Indian Names in Michigan.* Anne Arbor: University of Michigan Press, 1986.

Warrick, Gary. *A Population History of the Huron-Peton, A.D. 500–1650.* New York: Cambridge University Press, 2008.

Wright, J.V. "The Dougall Site." *Ontario Archaeology* 17 (1971): 3–23.

Archival Sources

Alley, G. Petition from Gerald Alley. *Simcoe County Land Book U.* Reel C161, page 41, July 1840, Simcoe County Archives, Midhurst, Ontario.

Archaeological and Historic Sites Board. Department of Public Records and Archives of Ontario.

Carman, A., and A. Sutherland. *Memorandum—Respecting the Indian Institutes and Boarding Schools in Ontario, Manitoba, the North and British Columbia,* 1850. United Church of Canada Archives, Victoria University Archives, Victoria, British Columbia.

Davis, Evelyn [Jamieson]. Interview transcript held at Orillia Museum of Art and History Archives.

Jarvis, S. Letter from Stephen [Samuel] Jarvis. Reel 2112, vol. 1, 22/6, June 1840, Simcoe County Archives, Midhurst, Ontario.

McPherson, A. Petition from Alan McPherson. *Simcoe County Land Book U.* Reel C106, page 99, August 1839, Simcoe County Archives, Midhurst, Ontario.

National Archives of Canada. Minutes of the General Council Meeting, Chief Yellowhead's Reading of the Wampum Belt Given by the Six Nations to the Chippewas during the French Regime. RG-10, vol. 1,011, pages 85–86. Courtesy of the Chippewas of Rama First Nation.

Orillia Public Library, Archives Transcription. "The Place of the Fence."

St. George, Laurent Quetton. "Dictionary and Journal of Trade," 1802. Baldwin Room, Toronto Reference Library, Toronto.

NEWSPAPERS AND PERIODICALS

Bowe, Aymond. "County Rail Plans on Track." *Collingwood Enterprise Bulletin*, April 8, 2009.

Bowles, Bob. "Regan House Welcomes New Additions." *Orillia Packet and Times*, November 9, 2012.

Burton, Pierre. "What's Wrong at Orillia: Out of Sight and Out of Mind." *Toronto Daily Star*, January 6, 1960.

Dawson, Dave. "Caldwell Skipped Last City Team at Brier." *Orillia Packet and Times*, March 20, 2013.

Johnson, Norm. *The Sword* 8, no. 8 (August 2011). Champlain Seniors Service Club, Orillia, Ontario.

Orillia Times. "The New Hotel." Editorial, May 1873. OMAH Collection.

Ross, Sarah. "Century-Old Atherley Arms Goes Up for Sale." *Orillia Packet and Times*, July 9, 2010.

Wilson, Jacob. "More Pioneer Reminiscences: Mr. Jacob Wilson Tells of Orillia's Early Days." *Orillia Packet*, March 7, 1912. Orillia Public Library Archives.

INTERNET SOURCES

Aboriginal Affairs and Northern Development Canada. "First Nations and the War of 1812." http://www.aadnc-aandc.gc.ca/eng/1345744367931/1345744406429.

Allen, William. "What's in a Name? The Story of the Words Mnjikaning and Ramah (now Rama)." Chippewas of Rama First Nation, 2008. http://www.mnjikaning.ca.

Arsic, Branka. "The Huron-Wendat Feast of the Dead: Indian-European Encounters in Early North America (review)." *Common Knowledge* 19, no. 1 (2013): 143–44. http://muse.jhu.edu.

Bray, Nancy. "After Waterloo: A Veteran in the Canadian Wilderness." Waterloo 200, 2011. http://www.waterloo200.org/after-waterloo-a-veteran-in-the-canadian-wilderness.

Chinese-Canadians: Profiles from a Community. "Wee Hong Louie." http://ccgwiki.vpl.ca/index.php/ccg_wiki/Wee_Hong_Louie.

City of Orillia. http://www.orillia.ca/en/doingbusinessinorillia/keyindustries.asp.

Cook, Wayne. "RE: Chapter 11, South Orillia." The First Years of Orillia Town. http://archiver.rootsweb.ancestry.com/th/read/CAN-ONT-SIMCOE/2000-03/0952858634.

Corbiere, Alan. "War of 1812 Bicentennial: More than Tecumseh." Ojibwe Cultural Foundation, 2012. http://www.ojibweculture.ca.

Dictionary of Canadian Biography. Vol. 9. "Musquakie." University of Toronto/Université Laval, 2003. http://www.biographi.ca/en/bio/musquakie_9E.html.

Doors Open Ontario. "Orillia," 2013. http://www.doorsopenontario.on.ca/Events/Orillia.aspx?NodeId=639&SiteCount=24&lang=en-CA.

Forsyth, Bruce. "Orillia's Forgotten Army Camp." Canadian Military History, 2007. http://www.militarybruce.com/unpublished-news/orillias-forgotten-army-camp.html.

Geography of Michigan and the Great Lakes Region. "Glacial Lake Algonquin." Michigan State University, Department of Geology. http://web2.geo.msu.edu/geogmich/glaciallake_algonq.html.

Gill, Hester Ann. "Memories of the Late Mrs. Leonard Wilson." Wayne Cook's Genealogy and Historical Plaques Page, 1929. http://www.waynecook.com/gill.html.

Government of Canada, Ministry of Agriculture. Census of Canada for 1870–71. Ottawa: J.B. Taylor, 1873. Internet Archive. http://archive.org/stream/1871981871fv11873engfra.

Government of Canada, National Defence and Canadian Forces. "The Grey and Simcoe Foresters." Chief Military Personnel. http://www.cmp-cpm.forces.gc.ca/dhh-dhp/his/ol-lo/vol-tom-3/par2/gsf-eng.asp.

Hall, Anthony J. "John Aisance." *Dictionary of Canadian Biography.* Vol. 7. University of Toronto/Université Laval, 2003. http://www.biographi.ca/en/bio/aisance_john_7E.html.

Husband, G.C. "John Jones Curran." Curran/Olivier Family History, 1970. http://www.mamisa.net/People/Curran%20JJ%20216.htm.

King's Highways of Ontario. "Ontario Highway 11-B, Orillia." http://www.thekingshighway.ca/Highway11B_orillia.htm.

Lapointe, Elizabeth. "Canadians in the American Civil War." GeneaBloggers, 2012. http://geneabloggers.com/canadians-american-civil-war.

Lovell, John. *Census of the Canadas for 1851–52.* Board of Registration and Statistics, Quebec. http://archive.org/stream/censusofcanadas01.

Marquis, Thomas Guthrie. "The Jesuit Missions: A Chronicle of the Cross in the Wilderness." *Chronicles of Canada.* Vol. 4. Edited by George M. Wrong and H.H. Langton. Toronto, 1916. http://www.fullbooks.com/The-Jesuit-Missions-1.html.

Bibliography

Michelaki, K., et al., "17th Century Huron Village Life: Insights from the Copper-Based Metals of the Ball Site, Southern Ontario, Canada." *Journal of Archaeological Science* (2012). http://dx.doi.org/10.1016/j.jas.2012.08.048.

Mnjikaning Fish Fence Circle. http://www.mnjikaningfishweirs.org/Mnjikaning.htm.

Orillia Heritage Centre. "Boyd's Horse." http://www.orilliaheritage.com/postcard-memories/item/36-w-boyd.

Orillia Opera House. "History." http://www.orilliaoperahouse.ca/History.html.

Orillia Power. "History." http://www.orilliapower.ca/AboutUs/History.aspx.

Orillia Rowing Club. http://www.orilliarowingclub.com/ORC_History.html.

Raymont, David. "Descendants of William Roe." United Empire Loyalists of Canada, 2012. http://www.uelac.org/Loyalist-Trails/2012.

Russel, Hilary. Leacock Museum Official Site. http://leacockmuseum.com/leacock-2.

St. James Church. "History." http://www.stjamesorillia.com/history.html.

Szijarto, Ken, "The MURF: A Brief History." Andrew4ward4's Blog, 2013. http://andrew4ward4.wordpress.com/murf-history-in-orillia.

Warren, William W. "A History of the Ojibwa People." Turtle Island Productions, 1885. http://www.turtle-island.com/native/the-ojibway-story.html.

Waugh, F.W. "Canadian Folk-Lore from Ontario." *Journal of American Folklore* 31, no. 119 (January–March 1918): 4–82. http://www.jstor.org/stable/534519.

Webster, Georgiana. "The Caldwells and Lucks." Reminiscing in Simcoe County, 2010. Wayne Cook's Genealogy and Historical Plaques Page. http://www.waynecook.com/memories.html#memory.3.

Wikipedia. "Augustus Jones." http://en.wikipedia.org/wiki/Augustus_Jones.

———. "Family Compact." http://en.wikipedia.org/wiki/Family_Compact.

———. "Koochiching County Minnesota." http://en.wikipedia.org/wiki/Koochiching_County,_Minnesota.

———. "Toronto Carrying Place Trail." http://en.wikipedia.org/wiki/Toronto_Carrying-Place_Trail.

Bibliography

Interview or Correspondence Sources

Allen, William A., Ojibwe elder. E-mail discussion with author, Burks Falls, Ontario, 2013.

Douglas, Mark, Ojibwe elder. Interview and discussion with author, Rama, Ontario, 2013.

Harvie, Charles. Interview and discussion with author, Orillia, Ontario, 2013.

Marshall, Jack. Interview and discussion with author, Orillia, Ontario, 2013.

Patterson, Al. Interview and discussion with author, Orillia, Ontario, 2013.

Quade, Wayne. Interview with author, Orillia, Ontario, 2013.

INDEX

A

Aisance 59, 60, 62, 64, 68, 70, 72
Alderville 77
Algonquin 15, 18, 23
Alley, Gerald 54, 55, 66
Anderson, Lance 143
Anderson, Thomas G. 56, 62
Anishinaabe 19, 23, 31, 60, 61, 79
asylums 51, 139, 140
Atherley 9, 13, 19, 22, 38, 56, 93, 99, 116, 121, 133, 144
Atherley Arms Hotel 121

B

Bailley, Honore 42, 46, 56
Baldwin, William Warren 40
Ball Site 25, 26
Barnfield Point 130
Barrie 9, 46, 51, 89, 91, 92, 99, 107, 109, 114, 121, 135, 150, 152, 156, 157

Base Borden 130
bays
 Fittons Road 15
 Georgian 15, 19, 21, 23, 35, 151, 156
 Matchedash 13, 21, 34, 35, 38, 45, 57, 71, 100, 104, 133, 149, 154
 Shanty 49
 Taronto 21
Belle Ewart 91
black flies 52
boarding schools 77
Bond Head, Sir Francis 62, 68, 73
bootleggers 119
Borland, Andrew 39, 40, 41, 42, 53, 56, 57, 72, 73, 74, 100
Boyd Horse, the 120
Brammer, Robert 88, 95
Brewery Bay 116, 120, 143, 159
Burton, Ida 91

INDEX

C

Cahaigué 24, 25
Camp 26 123
Camp Chatham 99
Canada Company 47, 49
Canada Wood Products 99
Carmichael, Franklin 143, 146
Carters Grill 126
Casino Rama 158
Champlain, Samuel de 9, 24, 25, 26, 29, 31, 35, 38, 51, 124, 126, 131, 151
Channel Cats 157
Civil War 92
clans of the Ojibwe 31
Clergy Reserves 46, 47, 89
Club Pavilion 104, 145
Colborne, Sir John (governor) 54, 62, 64, 86, 88, 100, 116, 133
Coldwater 9, 15, 21, 34, 35, 42, 46, 49, 51, 56, 59, 62, 64, 66, 68, 72, 88, 92, 133, 149
Constitution Acts 34, 46, 81
Copway, George 30, 31, 75
Couchiching Beach Park 86, 140, 159
Couchiching Point Hotel 93, 104
Cowan, George 38
Cramp, Wilbur 119
Crown Reserves 47
CWAC 126

D

Dallas, James 56
Davis, Evelyn 126
Daylight Savings 117
Dougall Site 27
Douglas, Irvine 119
Drinkwater, Captain J. 109
drunkenness 73, 86
Duck Soup Productions 147
Dumbbells, the 116

E

electricity 105, 106
E. Long and Company 88

F

Fahralloy 99
Fairall, Henry 116
Fairmile 127
Family Compact 43, 46, 70
farmers' market 150
farming 40, 55, 61, 62, 66, 67, 68, 78, 81, 88, 91, 140
Fesserton 38
fires 13, 31, 100, 104, 111, 158
Fittons Road 15
Fitton's Springs 104
Fitzgerald, F. Scott 99
400, the 133
Fraser, Henry 138
French River 21, 24, 35, 38
Frost, Leslie 110
fur trading 21, 24, 27, 30, 34, 40, 42, 43, 56, 68, 114

G

gathering place 22, 27, 30
Gaudaur, Antoine 9, 41, 42, 53, 147, 157
Gaudaur, Jake 157
General Council of Indian Chiefs 77
Georgian College 151, 156

Gill, Charles J. 45, 51, 52, 57, 66
Gill, Hester Ann 45, 51, 52, 57, 66
Gill, Jacob 9, 45, 51, 52, 53, 56, 57, 66, 72, 92
Goffat, Thomas 43
GO Transit 152
Gould, Glenn 99, 143, 144
Grand Trunk 92, 93, 140
Great Canadian Pine Belt 18
Greene, R.W.E. 146

H

Hale, C.H. 115, 117
Hallen, Eleanor 146
Hawkestone 13, 38, 49
Henry, C.A. 146
Herbert, Melville 116
Highway 11 15, 18, 133, 151
Highway 12 121, 133, 144
hired help 95
Hodge's Landing 49
Holland Landing 21, 35, 39, 41, 49, 51, 53, 72, 73, 91, 109
Hoy, Robert 87, 88
Hudson's Bay Company 41, 43
Humber 21, 34
Hunter, A.F. 18, 26, 27, 40, 114, 153
Hunter Boat Works 127
Huron 13
Huronia 13, 24, 62, 142, 151
Huronia Centre 142, 151

I

ice huts 131, 132, 153
Indian Agency 62
Infant School System 75, 76

J

Jamieson, Anna 45, 51, 54, 62, 66, 68, 78
Jarvis, Stephen (Samuel) 67, 70
Jesuit 26, 27, 30
Jones, Peter 55, 73, 75
Junior A Hockey League 157

K

King, Mackenzie 56, 60, 109, 110, 113
Kubota 151

L

Lac La Claies 21, 34
Lakehead University 144, 151, 156
lakes
 Algonquin 15
 Bass 13, 49
 Couchiching 13, 15, 18, 19, 21, 26, 27, 34, 35, 39, 40, 45, 56, 74, 75, 86, 91, 93, 94, 99, 104, 130, 131, 135, 140, 153, 157, 159
 Huron 13
 Huronia 13
 North Orillia 13
 Ontario 13
 Simcoe 7, 9, 13, 18, 19, 21, 23, 26, 27, 31, 34, 35, 38, 39, 40, 45, 46, 49, 51, 54, 55, 56, 57, 59, 60, 62, 64, 71, 77, 82, 91, 92, 93, 99, 109, 110, 123, 131, 132, 140, 152, 153, 157
 South Orillia 13
 Wendat 13

land agents 45, 46, 47
land grant policy 48
land grants 47
Langton, Anne 52
Laughton, William 39, 72
Leacock, Stephen 116
Le Caron, *Récollet* Priest 24, 26
library 144, 150
Lightfoot, Gordon 143, 144, 157
Lions Oval 144
local option 87, 116, 117, 125
logging camps 86
Long, Erastus 88
Louie, Walter H. 111
Loyalists 34, 35
lumber 22, 47, 48, 51, 53, 81, 84, 85, 86, 88, 89, 91, 92, 93, 95, 159
lumber camps 84, 86
lumbermen 47, 86

M

Maitland, Lieutenant Governor Peregrine 45
Manual Labour Schools 77
Manwaring, Mercy 9, 53, 54, 56, 75
Maple Leaf Club 125
Marchmont 64, 66
Mariposa 9, 11, 88, 99, 117, 120, 121, 143, 144, 145, 146, 147, 153, 156, 159, 160
Mariposa Arts Theatre 146
Mariposa Dance Company 147
Mariposa Folk Festival 144, 145
Matchedash Township 149
Mazinaw Rock 75
Métis 54, 55, 60, 64
Midland Railroad 92, 94, 132

militia 45, 56, 109, 110, 123
mills 66, 85, 86, 88, 95, 99, 131
missionaries 42, 59, 61, 68, 69, 75, 77, 78, 89
Mississaga Creek 35
Mississauga Street 88, 116, 120, 121, 144
Mnjikaning First Nation 157, 159
Moffat, Andrew 53, 54, 56, 75
Molson 155, 156
mosquitoes 51, 52
Mssr. Constant (George Cowan) 40
Munceytown 77
Muskokas 93
Musquakie 60, 70

N

Narrows, the 13, 19, 21, 22, 26, 27, 29, 30, 34, 35, 38, 39, 40, 41, 42, 45, 46, 53, 54, 59, 61, 62, 64, 66, 68, 71, 77, 81, 84, 92, 93, 121, 133, 152, 153, 159, 160
navvies 47, 87, 121
Newtown 45, 61
New York 13, 23, 24, 29, 40, 92, 99, 151
Northern Railroad 91, 93
North Orillia 13, 18, 43, 45, 57
Northwest Company 35, 42
Northwest Trading Company 34, 40

O

Oak Ridges Moraine 21
O'Brien, E.G. 49
Ojibwe 21, 22, 23, 24, 27, 29, 30, 31, 34, 35, 38, 40, 53, 56, 59, 60, 61, 62, 64, 67, 68,

INDEX

69, 70, 71, 75, 77, 78, 84, 89, 114, 156, 157, 158, 160
Ojibwe-Iroquois War 38
Old Mission House 89
Ontario Hospital School 140
Ontario Northland 152
Orchard Point 21, 26, 27, 38, 42, 113, 114, 115
Orchard Point Inn 115
Orillia Brewing and Malting Company 116, 117
Orillia Curling Club 113
Orillia Gun Club 113
Orillia Lunatic Asylum for Chronic Patients 139
Orillia Minor Hockey 156
Orillia Motor Campground 130
Orillia Museum of Art and History 7, 111
Orillia Opera House 106, 120, 143, 144, 146
Orillia Salvation Army 125
Orillia scrip 117
Orillia Township 27, 53, 117, 149, 154
Ormsby, James 49, 51
Orser, Brian 156
Orsi, Lou 153, 154
ossuaries 26, 27
 Orchard Point 26, 27
OTACO 127, 150, 155
Ottawa River 13, 21, 35

P

Penetang 23, 38, 52, 53, 64, 155, 156
Penetanguishene 23, 38, 52, 64, 156
Perch Derby 160
Pestalozzi, Johann Heinrich 76

Petun (Tionontate) 23
Price's Corners 138
prohibition 121
Puisaye, Comte de 39, 40
Purbrook (Steele estate) 111, 146

Q

Quinn farm 123

R

rafts of logs 87
Ragged Rapids 105, 106
Recreational Complex 155
Red Cross Hospital 27, 113, 114, 115
retirement 131, 143, 150, 151
Ritchey, Wellesley 49
rivers
 Algonquin 15, 18, 23
 Anishinaabe 19, 23, 31, 60, 61, 79
 Holland 21, 35, 39, 40, 41, 49, 51, 53, 72, 73, 91, 109
 Humber 21, 34
 Iroquois 9, 23, 24, 25, 29, 30, 31, 35, 38, 75
 Mnjikaning 9, 22, 157, 158, 159
 Northwest Company 35, 42
 Ottawa 13, 21, 29, 31, 35
 Rama 9, 18, 22, 31, 56, 60, 72, 74, 89, 92, 109, 116, 119, 147, 157, 158, 159, 160
 Rouge 21
 Severn 21, 35, 106
Roe, John 41, 53, 56, 57, 72
Roe, William 40, 41, 56, 72
Rotary Place 156, 157

S

schools 68, 75, 76, 77, 78, 111, 124, 130

Index

Scott, Jonathon 57, 66
Secord, J.P. 113
Severn Township 18, 45, 154
shanties 49, 51, 87, 121, 130, 135
shantymen 87, 135
Shilling, Arthur 143, 146, 147
Shilling, Big Chief 143, 146, 147
Shrapnel, Edward Scrope 146
Simcoe County Battalion 109
Simcoe, Elizabeth 31, 35, 132
Simcoe Foresters 109, 110, 123
Snake, Chief 59, 60, 64, 68, 73
Sneyd, Doug 146
Soldiers' Memorial Hospital 115, 116, 117
Southern Iroquois 23, 24, 29, 30
South Orillia 13, 18, 42, 43, 45, 53, 57, 133
South Orillia Bypass 133
speculation 42, 48, 92
stagecoaches 51
Stanton, Yudan 146
steamboats 81
Steele, Sir Samuel 111
Ste. Marie Among the Hurons 25
St. George, Laurent Quetton 39, 40, 42, 43
St. Germain, George 158
Stinson, Joseph 76
St. James 64, 89, 92, 146
Sunshine Sketches of a Little Town 117, 143
Swift Rapids 106

T

Tait, Andrew 86
Taronto 21, 34
temperance 86, 117

35th Simcoe Foresters 110
Thomson, John 86
Three Fires of the Anishinaabe 31
Tionontate 23, 24, 26, 29, 30
Toronto Carrying Place 21
tourism 89, 95, 99, 107, 132, 135, 151, 159
Trent-Severn Waterway 19, 130, 153
Tudhope Carriage Company 88
Tudhope-Everitt Automobile 99
Tudhope, J.B. 88, 95
Tudhope, William 88, 95
tunnels 116, 120, 121

U

Upper Canada 24, 33, 34, 45, 46, 48, 55, 61, 67, 68, 70, 86
Upper Canada Council Land Act 68

V

Vick and Sons 88

W

Wainwright, Sam 88
War Cake 129
Warren, William 31, 40
weirs 9, 19, 21, 29, 30, 38, 84
Wendat 13, 23, 24, 25, 26, 27, 29, 30, 35, 84
Wendat-Tionontate Confederacy 24
West Street South 155, 156
Wilson, Leonard 57
Wood, Elizabeth Wynn 146
World War II 123

Y

Yellowhead, Chief William 9, 13, 54, 55, 56, 59, 60, 64, 66, 68, 70, 72, 159
YMCA 125
Yonge Street 39, 46, 49, 55, 133, 135
York 21, 34, 40, 49, 51, 60, 109

ABOUT THE AUTHOR

Dennis C. Rizzo has written several local histories, as well as articles on the American Revolution and slave sanctuaries in New Jersey. He is a military brat, born in Monterrey, California, and is still deciding what he wants to be when he grows up. He ended up in New Jersey for fifty-odd years until his wife rescued him and brought him north. Dennis has lived in Orillia for three years as of this writing and has been involved in writing groups, mentoring and social issues. He is retired from government services, where he was involved at all levels of community programs and grants for people with developmental disabilities. He is a househusband, for whom designing school lunches that will delight his twin daughters has become an obsession. He has an older son who still lives and works in New Jersey. He is most proud of the research done for the present work, as well as for his book *Parallel Communities: The Underground Railroad in Southern New Jersey*, also from The History Press.

Visit us at
www.historypress.net

This title is also available as an e-book